POSTCARD HISTORY SERIES

Philadelphia's Fairmount Park

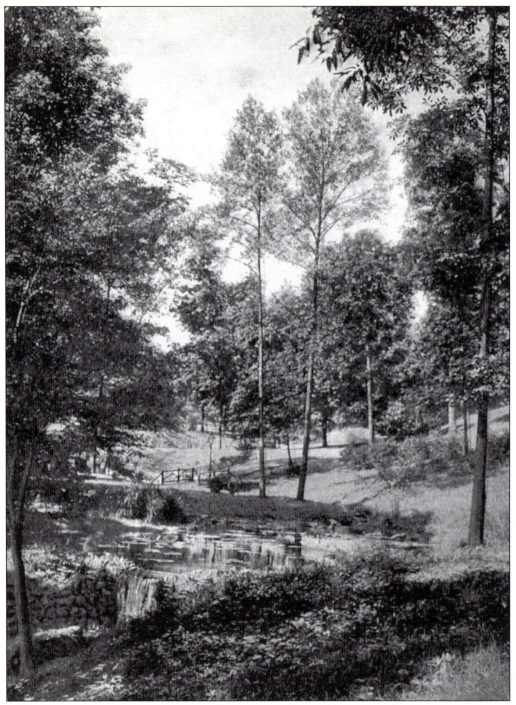

THE DELL. An act passed by the Pennsylvania General Assembly on March 26, 1867, authorized the City of Philadelphia to establish Fairmount Park as a permanent public place "for the health and enjoyment of the people." Eventually, the heart of the park system would include approximately 4,400 acres encompassing East and West Parks, the Wissahickon Valley, and the Schuylkill River. (Philadelphia Post Card Company, c. 1909.)

POSTCARD HISTORY SERIES

Philadelphia's Fairmount Park

James D. Ristine

ARCADIA

Copyright © 2005 by James D. Ristine
ISBN 0-7385-3794-2

First published 2005

Published by Arcadia Publishing,
Charleston SC, Chicago IL, Portsmouth NH, San Francisco CA

Printed in Great Britain

Library of Congress Catalog Card Number: 2004118340

For all general information, contact Arcadia Publishing:
Telephone 843-853-2070
Fax 843-853-0044
E-mail sales@arcadiapublishing.com
For customer service and orders:
Toll-free 1-888-313-2665

Visit us on the Internet at www.arcadiapublishing.com

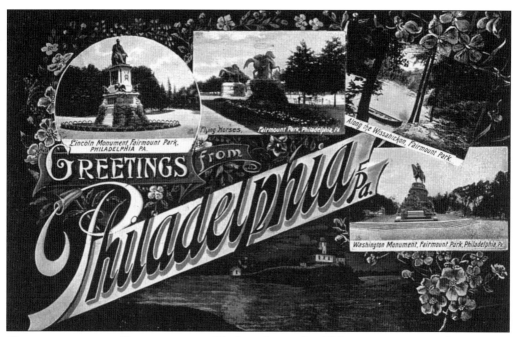

GREETINGS FROM PHILADELPHIA. During the early 20th century, postcards were an inexpensive way to communicate with friends and family. This souvenir postcard of Philadelphia shows multiple views taken in Fairmount Park. Such postcards helped to advertise some of the many attractions awaiting visitors. (Unknown, c. 1907.)

Contents

Introduction		7
1.	Along the Schuylkill	9
2.	East Park	25
3.	West Park	41
4.	The Zoological Garden	65
5.	The Wissahickon Valley	79
6.	Statues, Fountains, and Monuments	105
7.	Park Miscellany	121

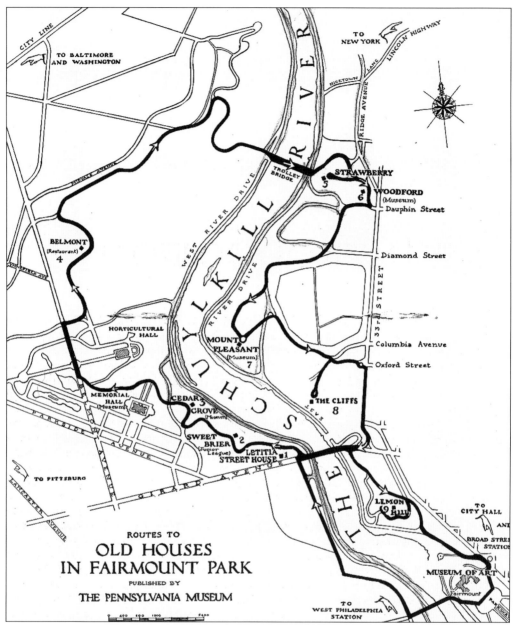

A Map of Fairmount Park. This map should help orient the reader to the locations of key landmarks within East and West Fairmount Parks. The Wissahickon Valley (not shown) is situated off to the upper right side of the map.

INTRODUCTION

In 1682, William Penn prepared the design for the city that was to be known as Philadelphia. As the city developed and grew, concern over the purity of the city's water supply and the need to provide residents with recreational parklands prompted the formation of what is now Fairmount Park.

The history of the park's development is somewhat complicated, as it was not created all at once but grew piecemeal over the years. In 1812, the city purchased five acres of land on the lower part of a hill known as Faire Mount. There, a waterworks was constructed. By 1828, the city had acquired 28 acres to help ensure the purity of the water supply and to serve as a public park. Then, in 1844, the Lemon Hill estate was purchased for a sum of $75,000. On September 28, 1855, the city council officially proclaimed the Lemon Hill estate a public park that was to be known as Fairmount Park. This was followed by an act of the Pennsylvania General Assembly on March 26, 1867, which authorized the establishment of Fairmount Park and stating that it be "maintained forever as an open public place and a park for the health and enjoyment of the people." Shortly thereafter, on June 3, 1867, the city formed the Fairmount Park Commission, whose duty was to oversee, protect, and manage the land. Since then, the park continued to increase in size as more land was acquired. One major acquisition was the 1,800 acres of the Wissahickon Valley in 1868. Today, Fairmount Park has grown to approximately 9,000 acres of recreational land scattered throughout the city. This book focuses on the heart of the park system, the 4,400 acres that constitute East and West Parks, the Wissahickon Valley, and a portion of the Schuylkill River.

The author has endeavored to provide the reader with a glimpse into the park's past, highlighting Philadelphia's golden age, the first quarter of the 20th century. Those familiar with the park in modern times will have the opportunity to see how it has evolved since that era. Today, as then, the park offers much to the citizens of Philadelphia. Besides providing a place in which to engage in all manner of outdoor recreational activities, it is home to some of the city's greatest cultural and historic treasures. From the famous Fairmount Water Works and nearby Boat House Row to the magnificent 18th-century mansions of East and West Parks and the varied historic buildings of the Wissahickon Valley, the park has a rich architectural tradition. This heritage has been preserved through the work of various organizations that have restored a number of homes and structures for public viewing.

Fairmount Park, site of the great Centennial Exposition of 1876, is also the birthplace of Philadelphia's great rowing tradition. With the Schuylkill Navy and a long history of regattas held on the river, the park is famous throughout the boating world. Home to America's first zoo, summer music concerts, the art museum, and one of the world's largest outdoor sculpture

collections, it is also a major cultural center. In 1872, the first private organization in the nation dedicated to promoting public art in an urban setting was founded here. Known as the Fairmount Park Art Association, it has been responsible for funding numerous works of art located throughout the park. Fairmount Park has from its very beginning been an inspiration to artists and poets. From its landscaped gardens and horticultural plantings to the natural rugged beauty of the Wissahickon Valley, the land offers the city dweller an escape from his urban environment.

The images contained in this book were captured by a number of postcard photographers. Through them, we can document how things once looked and thereby note the changes that have occurred over the years. For the benefit of the postcard collector, each image has been identified as to publisher (when known) and estimated date of publication.

It is the author's hope that the reader will come away with a better understanding of, and greater appreciation for, this unique and wondrous "jewel of Philadelphia," Fairmount Park.

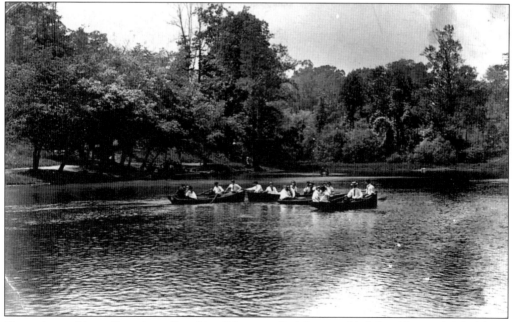

CHAMOUNIX LAKE. From its earliest days, Fairmount Park has provided the citizens of Philadelphia a means to escape the normal urban environment. The park furnishes the open spaces and natural settings necessary to engage in all manner of outdoor recreation. This real-photo postcard captures a group of park visitors boating on Chamounix Lake in 1913. (C. T. Brown, 1913.)

One
ALONG THE SCHUYLKILL

DOWN THE SCHUYLKILL. Flowing for 125 miles, the Schuylkill River eventually becomes the largest tributary of the Delaware River. In 1628, Dutch explorer Arendt Corssen became the first European to navigate this body of water, which he would name Schuyl Kil, meaning "hidden river." The Schuylkill River, dividing Fairmount Park into eastern and western sections, has played a significant role in the park's history. (H. C. Leighton, c. 1908.)

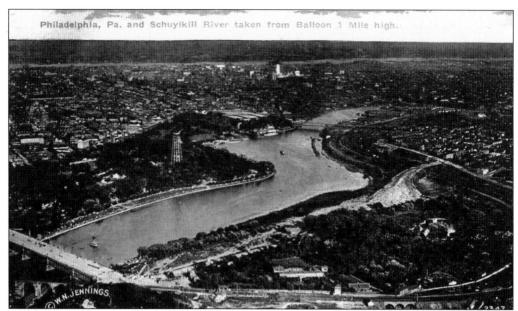

PHILADELPHIA, PENNSYLVANIA, AND SCHUYLKILL RIVER. During a balloon ride high above the city in 1893, photographer William N. Jennings was able to capture this view of the Schuylkill River as it makes its way to the Delaware River. This stretch of water runs between the Girard Avenue and Spring Garden Bridges. On the east side of the river stands the Lemon Hill observation tower. (Unknown, *c.* 1909.)

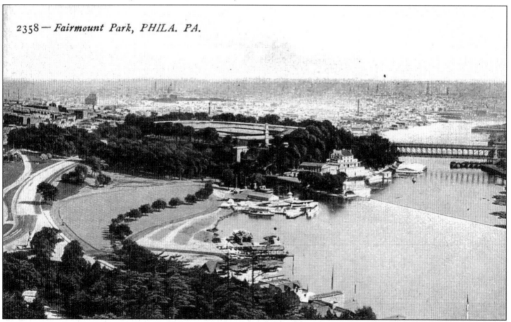

FAIRMOUNT PARK. This panoramic view was taken from the observation tower that once stood on Lemon Hill. It looks down the Schuylkill River to the Spring Garden Street Bridge, which marks the southern end of Fairmount Park. Behind the waterworks, atop the hill known as Faire Mount, is the large reservoir. It received water pumped up from the river below. (Souvenir Post Card Company, *c.* 1908.)

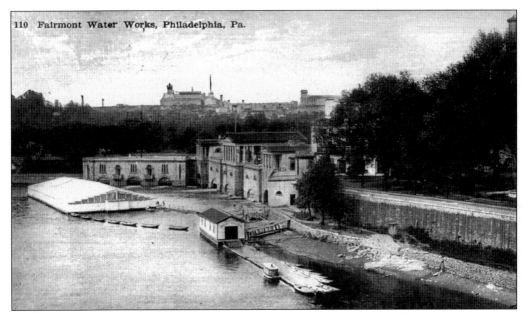

FAIRMOUNT WATER WORKS. A historic and engineering landmark, the Fairmount Water Works was the first municipal water system of its kind in the nation. It began pumping water to the city in 1815. Located on the east bank of the river, the waterworks was constructed in the classical Grecian style of architecture. Despite its early engineering advancements, the facility was considered obsolete by the year 1909 and was closed down. (Unknown, c. 1908.)

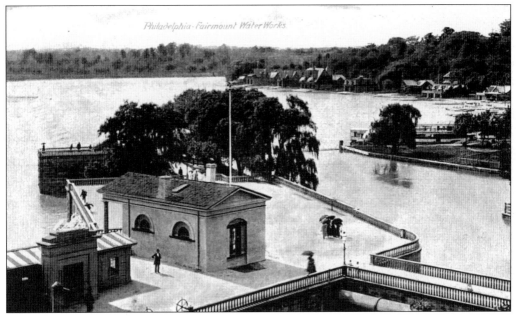

FAIRMOUNT WATER WORKS. Situated along one of the most picturesque sections of the river, the waterworks has long attracted visitors. During much of the 19th century, it was the nation's second most popular tourist site. People often came to walk the promenade and gaze at the river and the water flowing over the dam. Boat House Row, with its delightful houses, could be viewed just to the north. (World Post Card Company, c. 1909.)

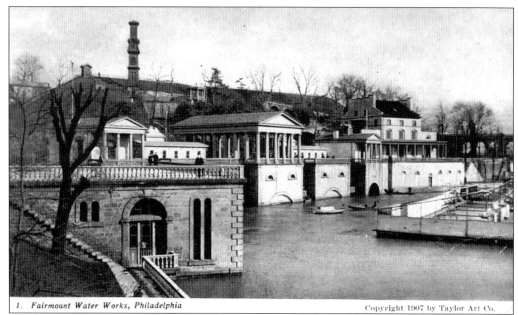

1. *Fairmount Water Works, Philadelphia* — Copyright 1907 by Taylor Art Co.

FAIRMOUNT WATER WORKS. Sitting on land acquired in 1812, the massive facility included five buildings. The two small classical "temples" at either end served as a meeting place for the water committee and quarters for the caretaker. The larger central section was known as the Graff Mansion, named for Frederick Graff, chief engineer of the complex. At one time, a ballroom located here was used to host social events. (Taylor Art Company, 1907.)

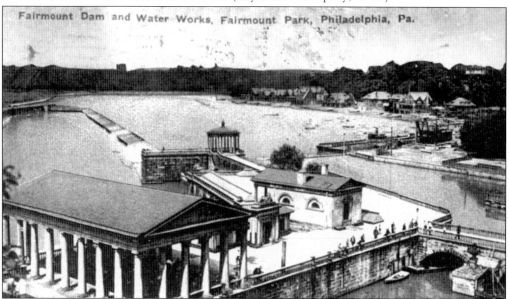

DAM AND WATER WORKS. In 1911, the city council passed a resolution stating that these magnificent buildings should be "preserved for all times." To that end, the city constructed the Philadelphia Aquarium on this site. This attraction was opened to the public on November 24, 1911, and operated until 1962. A public swimming pool built that year in the old millhouse was used until 1973. Recently renovated, the Fairmount Water Works Interpretive Center was opened on October 28, 2003. (S. M. Company, *c.* 1915.)

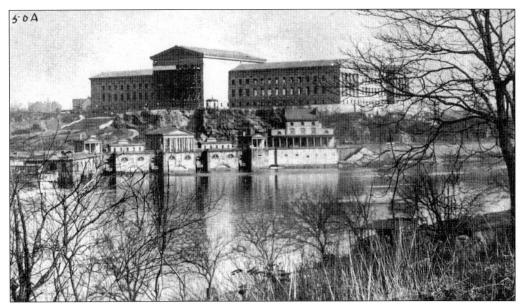

ART MUSEUM. Construction of the Philadelphia Museum of Art began in 1919 with funding provided by the city. Built on the former site of the water reservoir atop Fairmount Hill, the museum was designed in the style of a neoclassical Greek temple. Temporary galleries were first opened to the public in 1924, and since then, the museum and its collections have become world famous. (Pennsylvania Museum, 1928.)

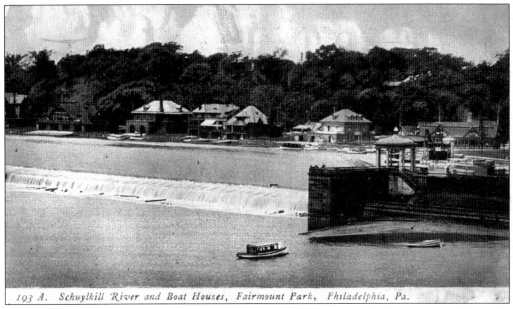

SCHUYLKILL RIVER AND BOAT HOUSES. The Fairmount Dam was built in 1821 to divert the flow of the river into the millhouse. This powered the pumps sending water to a 3-million-gallon reservoir (later expanded to hold 38 million gallons) atop Faire Mount, the present site of the art museum. This power source replaced the previous steam pumps, which proved to be too expensive and dangerous to operate. (Illustrated Post Card Company, c. 1910.)

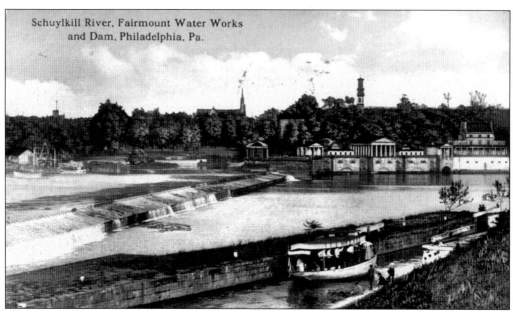

FAIRMOUNT WATER WORKS AND DAM. With the Fairmount Water Works in the distance, a boat loaded with passengers passes through the canal below the dam. This dam is actually a spillway, as it allows the river water to flow over it. Because the dam hindered boat traffic, the canal was constructed in order to give vessels the ability to travel up and down the river. (Unknown, *c.* 1912.)

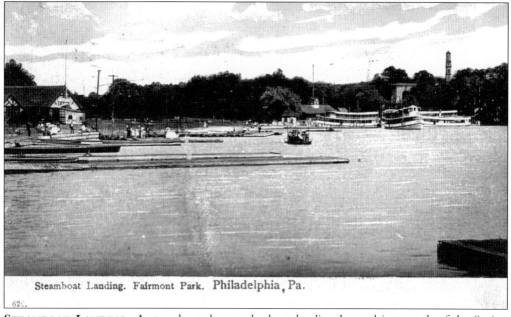

STEAMBOAT LANDING. A steamboat departs the boat landing located just north of the Spring Garden Street Bridge and the waterworks. These vessels transported passengers up and down the Schuylkill, dropping them off at any number of boat landings along the riverbanks. (Photo and Art Post Card Company, *c.* 1908.)

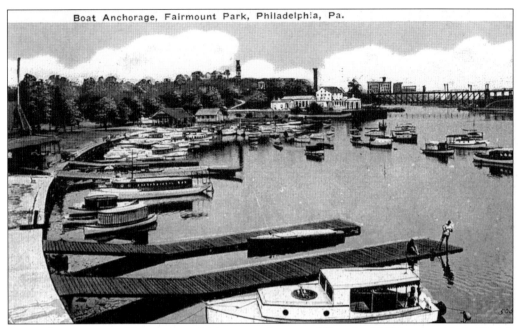

BOAT ANCHORAGE. The sender of this postcard wrote, "Here is old Fairmount Park. Which one of these boats will you have, there are plenty of choice." Boats of all descriptions, like those docked here, sailed on the waters of the Schuylkill. Everything from canoes and racing sculls to motorized vessels allowed people to enjoy the pleasure of river boating. (P. Sander, c. 1917.)

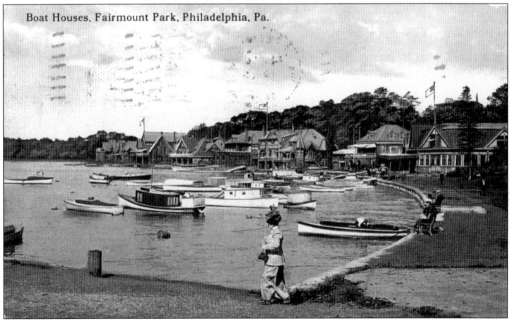

BOAT HOUSES. Seen from the waterfront are the privately owned buildings of the rowing clubs that made up the Schuylkill Navy. Located on Boat House Row, the present-day boathouses date from 1860 and show a variety of architectural styles. The earliest are Gothic Revival and Italianate styles, while those of the 1870s and 1880s were built in the Victorian Gothic style. Later houses incorporated the Mediterranean style. (Curt Teich Company, c. 1915.)

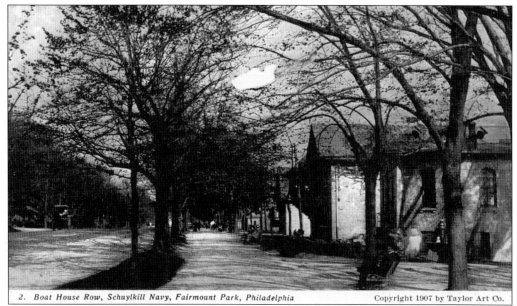

2. Boat House Row, Schuylkill Navy, Fairmount Park, Philadelphia — Copyright 1907 by Taylor Art Co.

BOAT HOUSE ROW. Boat House Row is home to Philadelphia's famous rowing clubs, known collectively as the Schuylkill Navy. Established in 1858 by nine boating clubs, the organization is now the oldest sports governing body in the nation. Regattas have been held continuously by this group since 1859, except during the years of the Civil War. (Taylor Art Company, 1907.)

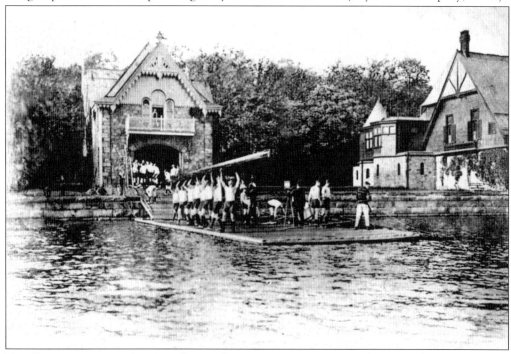

THE BOAT HOUSE. University of Pennsylvania oarsmen prepare to place an eight-man shell into the river. Another boat is already in the water on the south side of the dock. Behind them stands their boathouse, dating from 1878. This stone Victorian Gothic building was designed by the Wilson Brothers architectural firm and cost $12,000. (Houston Club, c. 1914.)

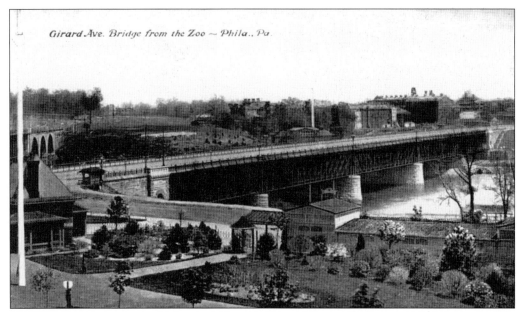

GIRARD AVENUE BRIDGE. This 1,000-foot-long wrought-iron bridge at Girard Avenue was built in 1874 at a cost of $1,486,000. With a width of 100 feet and enough room for seven lanes of carriage traffic, it was the world's widest bridge. So wide was it that even in the year 1919 it was the only bridge within the park's boundaries over which livestock were permitted to be herded. (Unknown, c. 1914.)

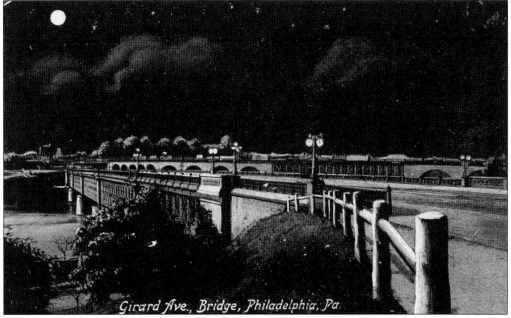

GIRARD AVENUE BRIDGE. Here is a wonderful nighttime view of the bridge, as seen from one of its approaches. It was sometimes referred to as the Centennial Bridge, because of its extensive use by visitors traveling to the grounds of the Centennial Exposition in 1876. In its day, the bridge was considered an engineering marvel and proved something of an attraction on its own. (Illustrated Post Card Company, c. 1910.)

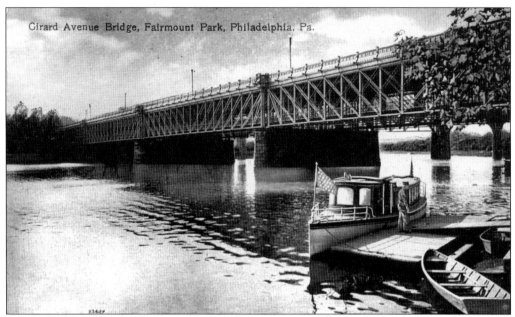

GIRARD AVENUE BRIDGE. This view of the Girard Avenue Bridge was taken from water level. A new bridge replaced this one in 1971. In the new construction, the builders were able to incorporate some of the original stone piers and ornamental ironwork from this, the 1874 span. (Unknown, *c.* 1912.)

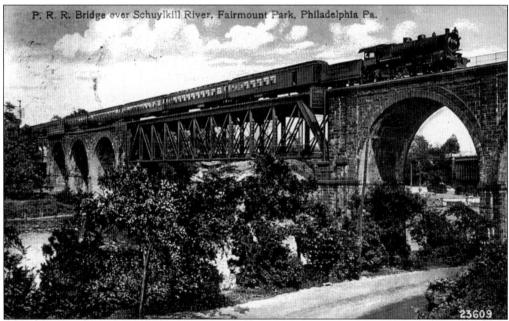

PENNSYLVANIA RAILROAD BRIDGE. Crossing the river just north of the Girard Avenue Bridge is the picturesque Pennsylvania Railroad Bridge, built by T. L. Eyre in 1875. With a length of 1,140 feet, it stands 40 feet high. According to a 1919 park guidebook, it was just one of nine bridges that spanned the Schuylkill River within the boundaries of Fairmount Park. (Post Card Distribution Company, *c.* 1912.)

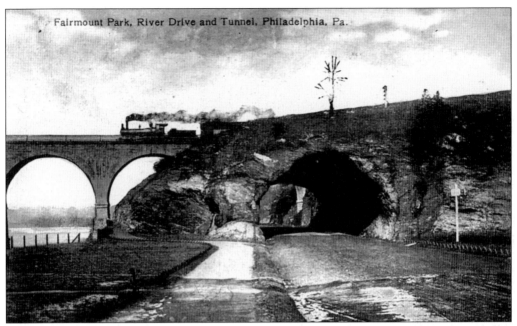

RIVER DRIVE AND TUNNEL. A steam locomotive and train heading west passes over the Pennsylvania Railroad Bridge. This view, taken from East River Drive (now Kelly Drive), was a scene often captured by postcard photographers. Passing through the rocky hillside, the tunnel was constructed in 1871 to allow travel along the river. (Post Card Distribution Company, *c.* 1910.)

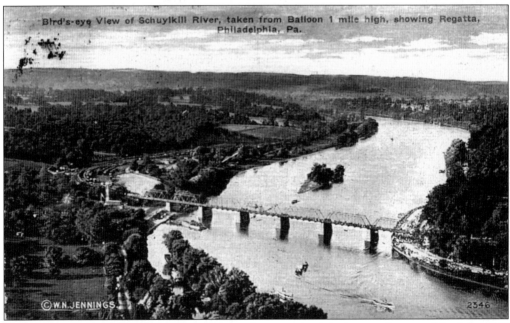

BIRD'S-EYE VIEW OF THE SCHUYLKILL. Looking northward, this aerial view of the Schuylkill River was taken from a balloon floating high above Fairmount Park. Seen are the Columbia Railroad Bridge and Peter's Island. This is an area of the river where rowing regattas were, and still are, routinely held. (Post Card Distribution Company, *c.* 1909.)

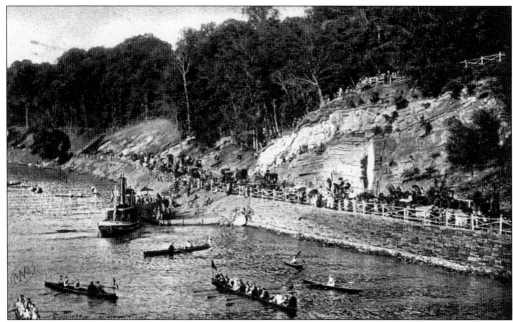

REGATTA. Propelling a boat by paddle or oar on the Schuylkill River has long been a popular pastime and sport. Artist Thomas Eakins (1844–1916), a native Philadelphian, helped to immortalize rowers and scullers with his series of paintings on the subject in 1874. The Schuylkill Navy was holding organized regattas as early as 1859. (Metropolitan News Company, c. 1906.)

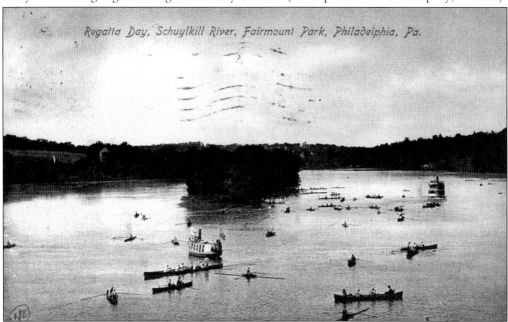

REGATTA DAY. The Schuylkill Navy, with its long history of sponsoring rowing regattas, has helped make Philadelphia world renowned in the sport of sculling. Rowing competitions have included a variety of racing craft. Typically, sculling events have featured singles, doubles, fours, and eights. In this postcard view, a mixture of these boats is visible. (Metropolitan News Company, c. 1906.)

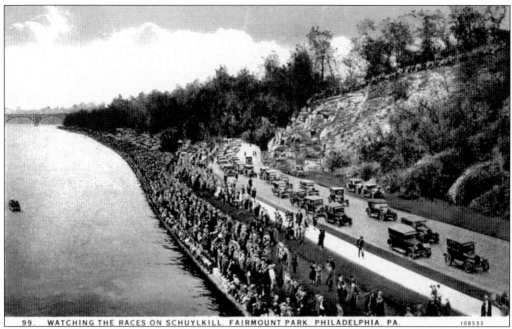

99. WATCHING THE RACES ON SCHUYLKILL, FAIRMOUNT PARK, PHILADELPHIA, PA.

WATCHING THE RACES. Regattas on the river, especially those held on an annual basis, would often attract hundreds of participating rowers and thousands of spectators. Spectators would usually gather along East River Drive to watch and cheer on their favorite rowing clubs. Even today, these events are popular attractions, drawing people from around the world. (Sabold-Herb Company, c. 1925.)

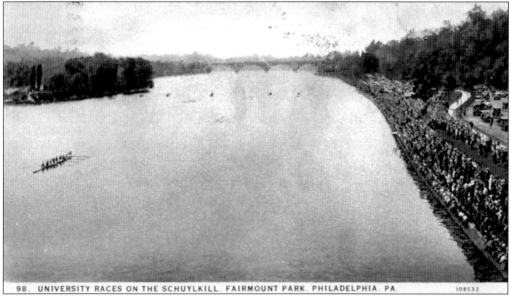

98. UNIVERSITY RACES ON THE SCHUYLKILL, FAIRMOUNT PARK, PHILADELPHIA, PA.

UNIVERSITY RACES. A huge crowd stretches along the riverbank across from Peter's Island to watch the day's events. Over the years, the course lengths have changed. From 1899 to 1910, the distance was set at one and a half miles; in 1911, the national course was changed to one and a quarter miles. After a few other modifications, the distance was ultimately set at 2,000 meters in 1964. (Sabold-Herb Company, c. 1925.)

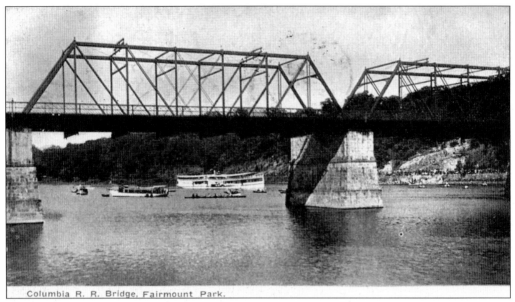

COLUMBIA RAILROAD BRIDGE. The Phoenix Bridge Company erected hundreds of railroad bridges and viaducts all across the United States, Canada, and Latin America, until going out of business in 1962. This bridge, built by the company in 1874, is 600 feet long, 30 feet wide, and 32 feet high. In this view, a rowing regatta occurs just north of the bridge. (Goggins, c. 1906.)

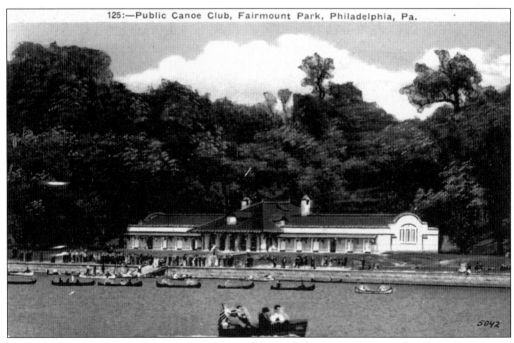

PUBLIC CANOE CLUB. Situated on the east bank of the river, just south of the Strawberry (Park Trolley) Bridge, is the Public Canoe Club building. In this view, people are positioned along the shoreline, watching as a line of canoes glides past the boathouse and heads downriver. (P. Sander, c. 1925.)

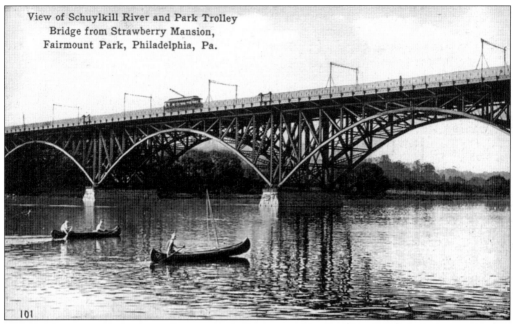

VIEW OF SCHUYLKILL RIVER AND PARK TROLLEY BRIDGE. Two canoes approach the Park Trolley (Strawberry) Bridge, built in 1897 by the Phoenix Bridge Company. Constructed at a cost of $200,000, the bridge is 900 feet long, 76 feet wide, and 52 feet high. Its decorative iron railing adds a pleasing visual touch. (Philadelphia Post Card Company, c. 1910.)

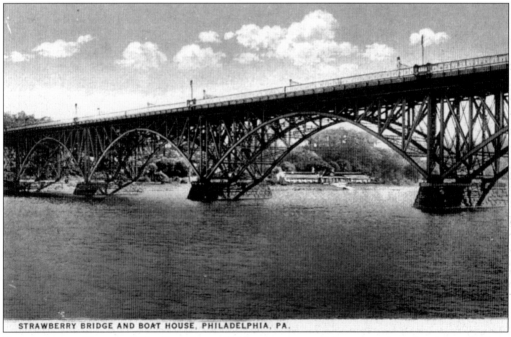

STRAWBERRY BRIDGE. The Strawberry Bridge was part of the approximately nine-mile-long trolley system running through Fairmount Park. It was particularly used to carry passengers to Woodside Park on the west side of the river. This amusement park, opened by the Fairmount Park Transportation Company, operated until October 1955. (Sabold-Herb Company, c. 1925.)

SCHUYLKILL RIVER. To the Lenni Lenape Indians, the Schuylkill River was known as the Ganshowahanna, meaning "falling waters." Here, near Strawberry Hill north of the Park Trolley Bridge, the river looks calm and peaceful. It continues to flow south toward Philadelphia, where it eventually serves as a source of drinking water. (Illustrated Post Card Company, c. 1908.)

BALTIMORE & OHIO RAILROAD BRIDGE. Located at the northern end of Fairmount Park, this stone-arched bridge was constructed in 1889. The Pencoyd Company was the builder, with the Nolan Brothers Company contracted to complete the substructure. Standing 35 feet high, the bridge is 29 feet wide and 775 feet long. (Goggins, c. 1904.)

Two
EAST PARK

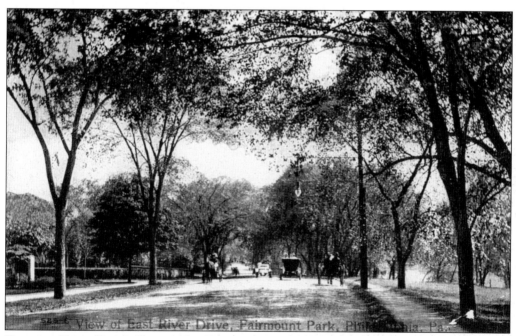

VIEW OF EAST RIVER DRIVE. East River Drive, which has since been renamed Kelly Drive, serves as a corridor into East Park. This portion of Fairmount Park occupies a relatively narrow strip of land extending along the river, as well as acreage on the highlands above, over to 33rd Street. Here, on the east bank of the Schuylkill River, the park had its origins. (Unknown, c. 1910.)

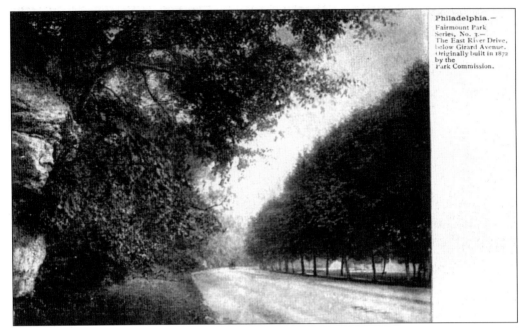

THE EAST RIVER DRIVE. This section of East River (Kelly) Drive is located below the Girard Avenue Bridge, near the southern end of East Park. The road was built by the Fairmount Park Commission to allow traffic to travel along the river's edge. This provided parkgoers a scenic route with which to access the parklands on this side of the river. (Stern & Company, c. 1904.)

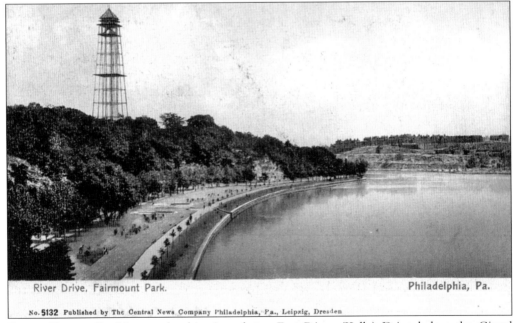

RIVER DRIVE. Looking south, this view shows East River (Kelly) Drive below the Girard Avenue Bridge. On the left stands a tall observation tower situated on Lemon Hill. This was one of several towers that had been built for use during the Centennial Exposition. Now long gone, these lookouts allowed for wonderful panoramic views of the park and the city. (Central News Company, c. 1907.)

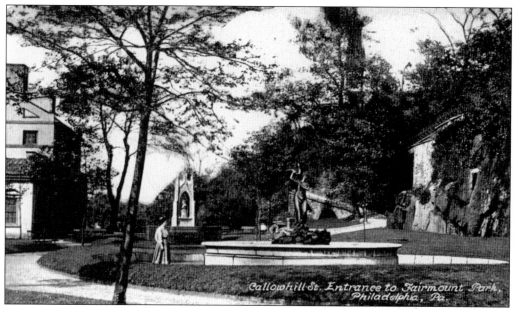

CALLOWHILL STREET ENTRANCE. The brick-paved walkway at the Callowhill Street entrance to East Park passes by the rear of the Graff Mansion, seen on the left. A woman stands, admiring a fountain containing the statue *Water Nymph and Bittern*, by William Rush. This fountain has since been removed. Behind her is the memorial housing the bust of Frederick Graff, the chief engineer and designer of the Fairmount Water Works. (Unknown, c. 1910.)

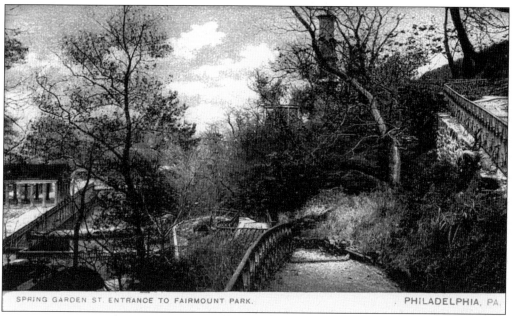

SPRING GARDEN STREET ENTRANCE. Entering the park by means of the Spring Garden Street entrance, one passes by the old waterworks, seen on the left. Visible over the trees in the distance is the tower of the Spring Garden Water Works, located on East River Drive. That site is now occupied by the Glendinning Rock Garden, established in 1936. (Philadelphia Post Card Company, c. 1905.)

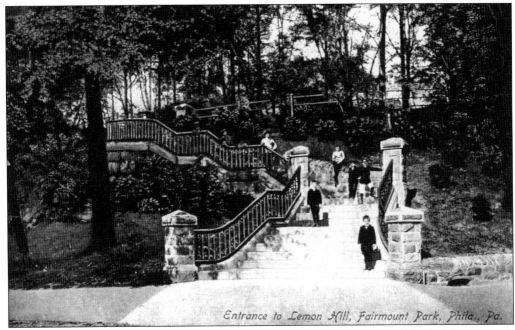

ENTRANCE TO LEMON HILL. This grand stairway allows visitors to ascend the heights to reach the Lemon Hill Mansion. The mansion, which overlooks the Schuylkill River, was constructed in 1799 as part of the estate of Henry Pratt. The 1844 purchase of the property by the City of Philadelphia for $75,000 led to the birth of Fairmount Park. (P. Sander, c. 1909.)

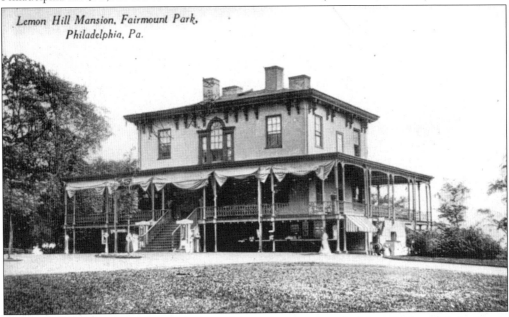

LEMON HILL MANSION. The Lemon Hill Mansion is a wonderful example of Federal-style architecture. Situated on Kelly and Sedgeley Drives, the three-story home features distinctive oval-shaped rooms with curved fireplaces on each floor. Its name derived from the lemon trees that were once grown here, along with other exotic plants, in the estate's greenhouses. (Unknown, c. 1910.)

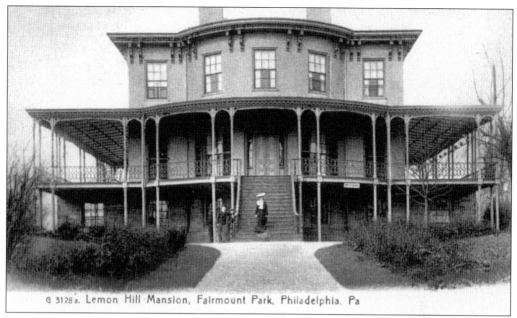

LEMON HILL MANSION. In this view of the mansion, a finely dressed woman descends the steps leading to the second-floor entranceway. Since 1957, the mansion has been administered by the Colonial Dames of America. Filled with representative furniture made by Philadelphia craftsmen of the 18th century, the estate is now open all year for public tours. (Rotograph, c. 1905.)

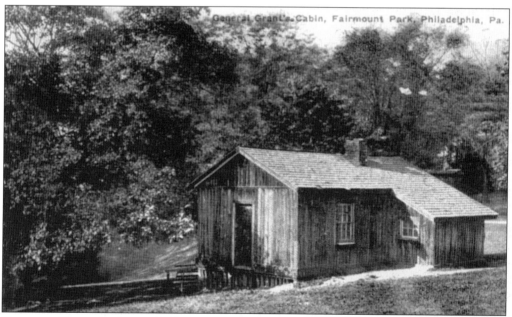

GENERAL GRANT'S CABIN. Built in November 1864, this small, two-room log cabin originally stood in City Point, Virginia. There, it was occupied by Gen. Ulysses S. Grant, commander of the Union army. In this cabin, Grant planned and issued orders for the final battles of the Civil War. (Unknown, c. 1910.)

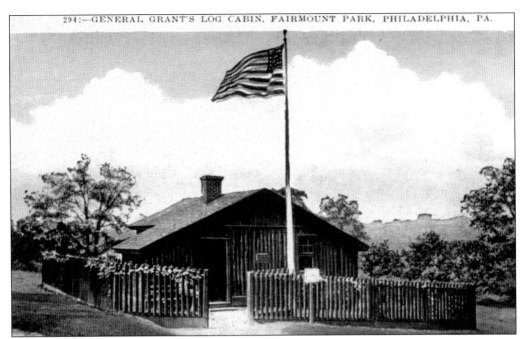

GENERAL GRANT'S CABIN. At the end of the Civil War, General Grant gave this cabin to his friend George Stuart. Stuart's heirs then presented it to the park in 1898. It was placed south of the Girard Avenue Bridge, across the road from the Sedgeley guardhouse. In the late 1970s, the cabin was dismantled and returned to its original site in City Point, Virginia. (P. Sanders, c. 1925.)

RIVER DRIVE. Heading north on East River (Kelly) Drive, which is about five miles in length, park visitors traveled through the rock tunnel carved in the hillside. On the other side of the tunnel is the Pennsylvania Railroad Bridge. To the right stands the old water-treatment plant at Brewery Hill Drive. (Detroit Publishing Company, 1905.)

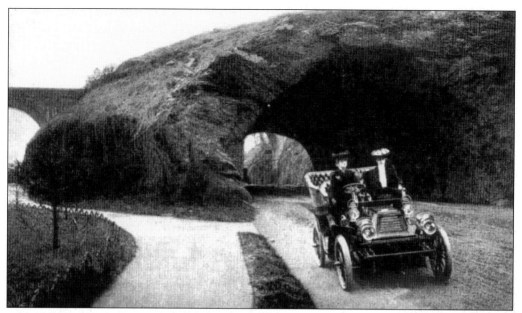

EAST RIVER DRIVE AND TUNNEL. Two women have stopped their motor vehicle just south of the rock tunnel in order to pose for the photographer. When this postcard was published, the automobile was something of a rarity. In 1908, only 25,000 cars were owned in all of Pennsylvania. At an average cost of $2,108, they were considered by many to be a "toy" for the upper class. (World Post Card Company, c. 1904.)

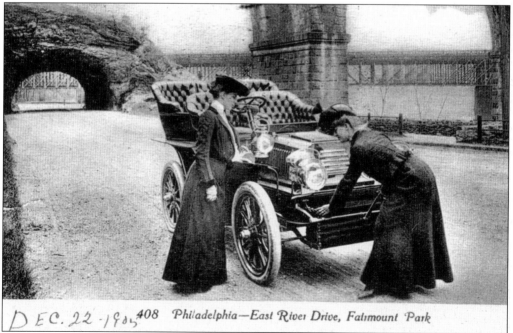

EAST RIVER DRIVE. In this scene, the same two women attend to their vehicle while stopped on the north side of the rock tunnel. The Girard Avenue Bridge can be observed in the distance. During the early 1900s, automobiles were restricted to a speed limit of seven miles per hour on park roadways. (World Post Card Company, c. 1904.)

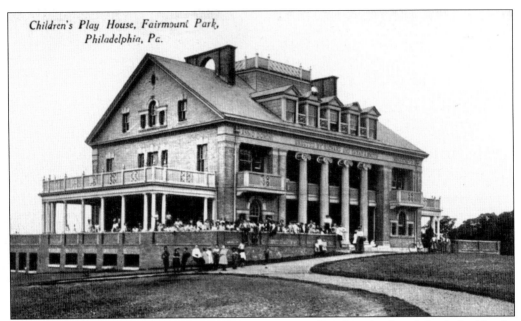

CHILDREN'S PLAY HOUSE. With funding from the wills of Richard and Sarah Smith, the Children's Playhouse was opened to the public on July 23, 1899. It was built specifically as a place for the city's youth to come and play, free of charge. Since then, the house and its six acres of playgrounds have hosted more than 10 million children. (Unknown, c. 1910.)

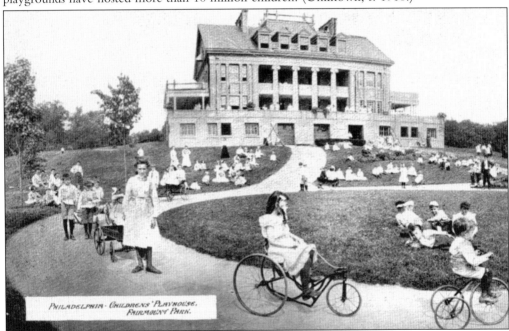

CHILDREN'S PLAYHOUSE. This wonderful postcard view shows a great number of children enjoying the day at the Children's Playhouse. One of the most popular pieces of equipment was a 12-foot-wide giant sliding board, erected in 1905, which could accommodate up to 10 children across. Outside activities such as tricycle riding also thrilled the children. (World Post Card Company, c. 1905.)

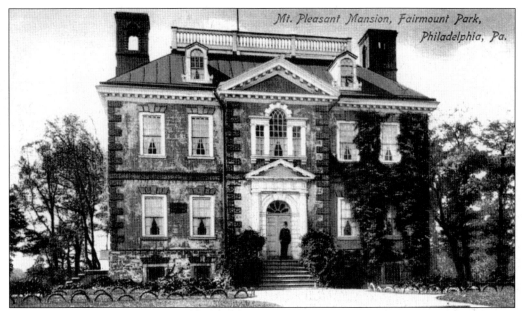

MOUNT PLEASANT MANSION. Built in 1761 by John MacPherson, a Scottish sea captain and privateer, this 120-acre estate became known as Mount Pleasant. Many notable families occupied the property until it was taken over by the park commission in 1868. One famous owner was Benedict Arnold, who purchased the property in 1779 as a gift for his bride, Mary Shippen. However, he never had the opportunity to actually live here. (P. Sander, c. 1907.)

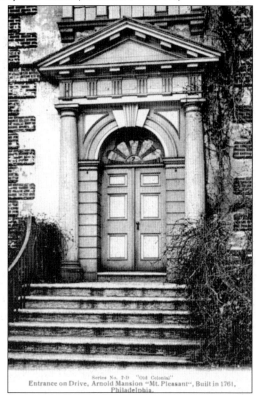

ENTRANCE ON DRIVE. This closeup reveals the front door of the residence, which has at times been referred to as the Arnold Mansion. The home, a superb model of the Georgian style of architecture, exemplifies balance and symmetry of design. The interior possesses some of the finest examples of carved woodwork still in existence from that era. (Architectural Post Card Company, c. 1915.)

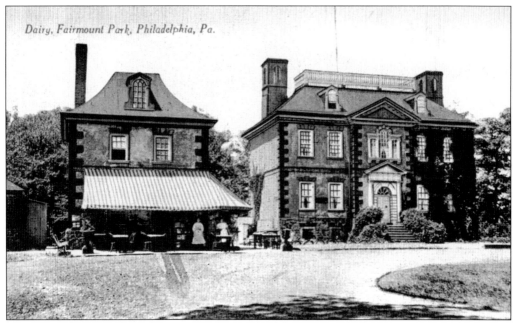

DAIRY. In addition to the main house, Mount Pleasant had two large outbuildings. One of these became a refreshment stand known as the Dairy. The main house was beautifully restored in 1926 through the efforts of Charles H. Ludington and the Philadelphia Museum of Art. The building is now open for tours. (Unknown, c. 1910.)

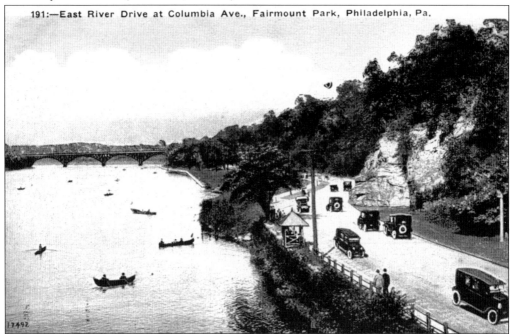

EAST RIVER DRIVE. Vehicular traffic proceeds both northward and southward along this stretch of East River (Kelly) Drive at Columbia Avenue. In the distance is the Strawberry Bridge. A Sunday drive along the five-mile river route was for many an enjoyable outing and family custom. (P. Sander, c. 1920.)

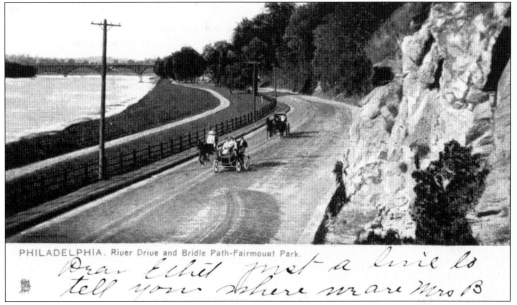

RIVER DRIVE AND BRIDLE PATH. Before automobiles became commonplace, horse-drawn vehicles conveyed people through the park. In this early scene, an open-air motorcar shares the road with two carriages pulled by horses. Park regulations required operators of motor vehicles to come to a full stop if they should make any horse "restive or frightened." (Raphael Tuck & Sons, c. 1906.)

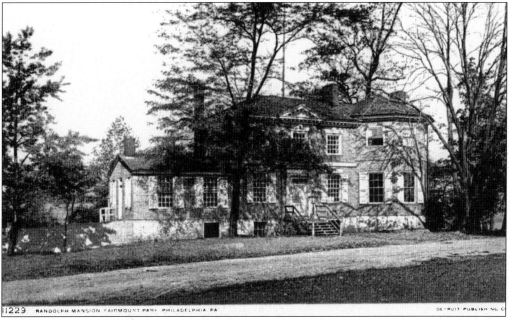

RANDOLPH MANSION. Situated on Edgely Drive and Fairmount Avenue, this Georgian-style home was erected by Joseph Shute c. 1764–1767. He named the estate Laurel Hill in recognition of the abundant growths of laurel on the hillside. In the 19th century, two additions were made to the home, including an unusual octagonal section on the north end. (Detroit Publishing Company, c. 1907.)

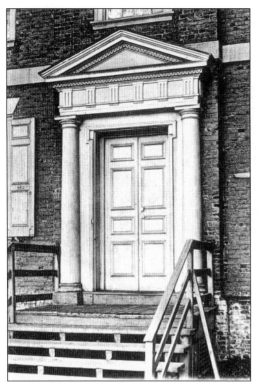

THE RANDOLPH MANSION. This closeup view of the entranceway to the Randolph Mansion shows many of the fine architectural details typical of the Georgian style of architecture. Over the years, the building has housed several prominent families. Dr. Jacob Randolph and his family held ownership of the property until it was acquired by the park commission in 1869. (Architectural Post Card Company, *c.* 1915.)

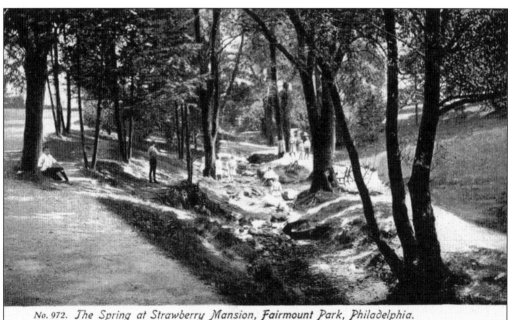

No. 972. The Spring at Strawberry Mansion, Fairmount Park, Philadelphia.

SPRING AT STRAWBERRY MANSION. Under the cool shade of trees, a natural spring near Strawberry Mansion offered welcome relief from the summer heat. One of approximately 160 natural springs located throughout Fairmount Park, it was a source of refreshing drinking water for park visitors. (Philadelphia Post Card Company, *c.* 1907.)

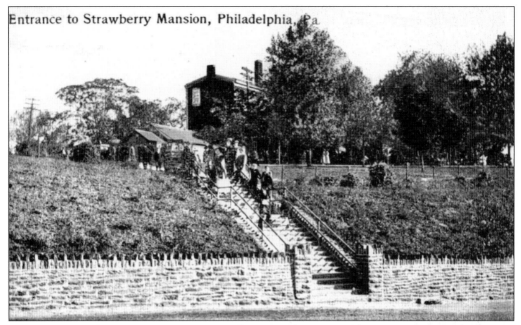

ENTRANCE TO STRAWBERRY MANSION. A stone stairway provides an entranceway leading up to the park's largest mansion. Strawberry Mansion stands on high ground at 33rd and Dauphin Streets. Built by a Quaker judge named William Lewis in 1798, the house and its grounds were incorporated into the park in 1867. (Unknown, *c.* 1910.)

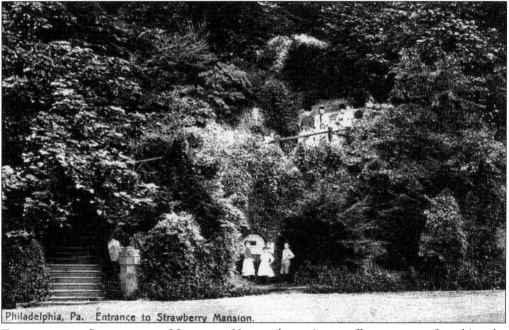

ENTRANCE TO STRAWBERRY MANSION. Yet another stairway offers a means of reaching the higher ground where Strawberry Mansion stands overlooking the Schuylkill River. Park visitors stop to pose for the photographer amidst heavy vegetation that almost hides the stairway from view. (O. S. Bunnell, *c.* 1910.)

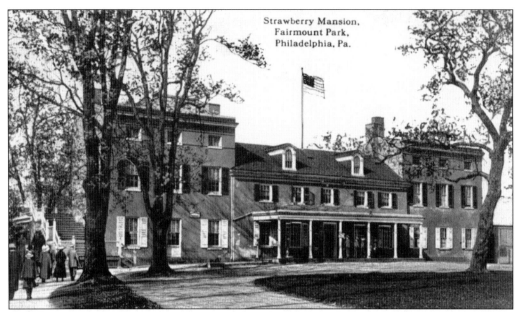

STRAWBERRY MANSION. The home's Federal-style appearance was changed *c.* 1825, when two large Greek Revival wings were added. The mansion derives its name from the Chilean strawberry plants grown here by the Hemphill family. During the 1840s, the home was a restaurant well known for serving "strawberries and cream." (Post Card Distribution Company, *c.* 1910.)

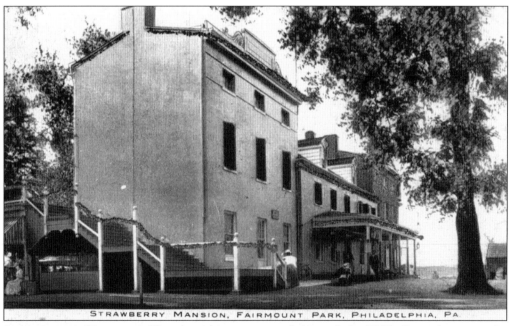

STRAWBERRY MANSION. The estate became part of the park in 1867. Over the years, the mansion has served as a restaurant, police court, and park guard recreational area. In 1929, a group named the Women's Committee of 1926 renovated the building. Today, the mansion is open for tours and is known for the large collection of 19th-century toys and dolls housed in its attic. (Illustrated Post Card Company, *c.* 1906.)

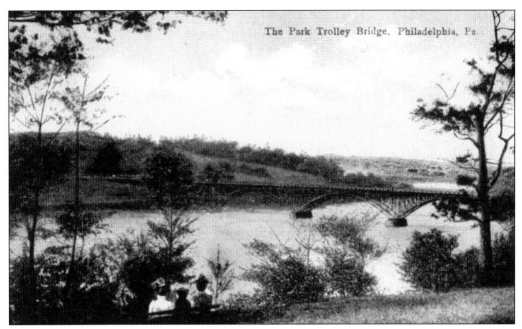

THE PARK TROLLEY BRIDGE. At the top of Strawberry Hill, three people sit on a park bench, gazing down on the river and the Park Trolley (Strawberry) Bridge in the distance. At one time, a boat landing situated on the riverbank below allowed Strawberry Hill visitors to arrive by steamboat. (Unknown, c. 1909.)

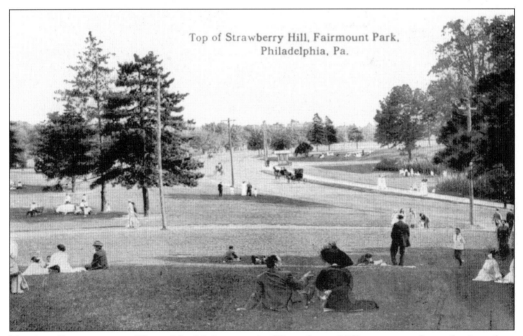

TOP OF STRAWBERRY HILL. The high ground of Strawberry Hill was a popular gathering place for park visitors, as it allowed a fine view of the river below. It was a favorite locale for church picnics and suppers, as well as other types of social activities. The site also had a carousel and swings. (Post Card Distribution Company, c. 1912.)

39

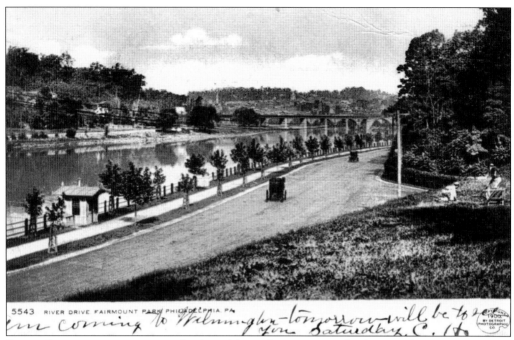

RIVER DRIVE. Young trees, neatly planted by park commission landscapers, line the sides of the unpaved East River (Kelly) Drive. Present-day park visitors continue to enjoy the picturesque views provided by this wonderful roadway, which parallels the Schuylkill River for about five miles. (Detroit Publishing Company, 1900.)

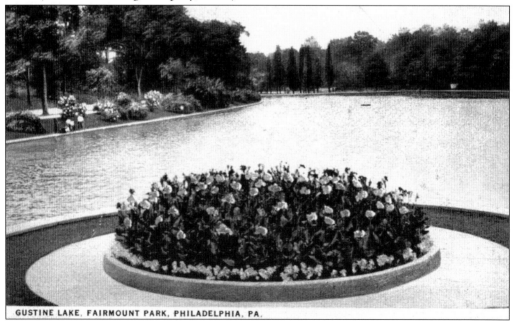

GUSTINE LAKE. Situated at the northern tip of East Park, Gustine Lake was found just north of the Queen Lane pumping station. The lake served as a popular spot for swimming in summer and ice-skating in winter. In the 1950s, the lake was converted into a formal swimming pool. It was closed down in the 1980s. (Sabold-Herb Company, c. 1925.)

Three
WEST PARK

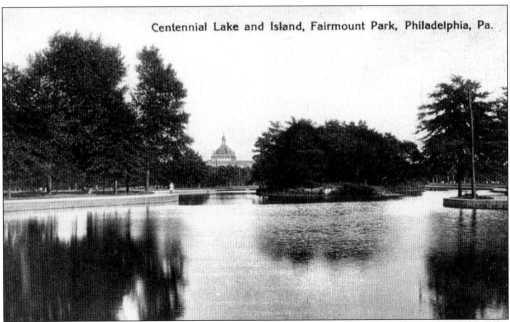

CENTENNIAL LAKE AND ISLAND. West Park extends along the western side of the Schuylkill River from Spring Garden Street on the south to City Avenue on the north. A combination of natural woodlands and developed areas, the park hosted the 1876 Centennial Exposition. The dome of one of that event's major buildings, Memorial Hall, can be seen in the distance across Centennial Lake. (Leighton & Company, c. 1909.)

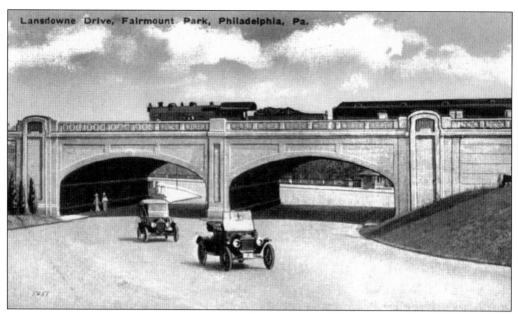

LANSDOWNE DRIVE. As a train travels across the railroad overpass, two automobiles head onto Lansdowne Drive. Running west a short distance before turning north, the road is one of the major routes into the heart of West Park. Seen through one of the arches, on the other side of the bridge, is a small Fairmount Park Guardhouse. (Unknown, *c.* 1916.)

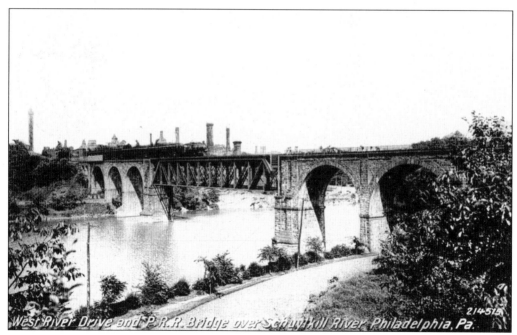

WEST RIVER DRIVE AND PENNSYLVANIA RAILROAD BRIDGE. Looking eastward from West River Drive, this view shows a passenger train crossing the Pennsylvania Railroad Bridge. From here, just above Girard Avenue, West River Drive heads north following the curves of the Schuylkill River until it reaches City Avenue. (Leighton & Valentine, *c.* 1911.)

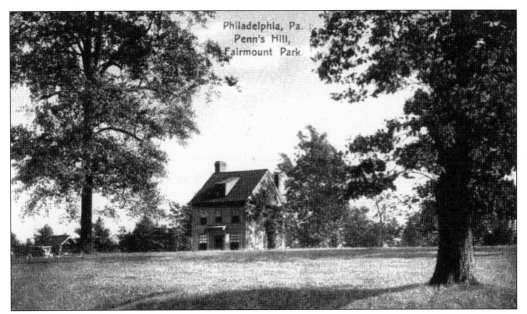

PENN'S HILL. Standing atop Penn's Hill is a small, two-story brick home known as the Letitia House. Built by carpenter John Smart in 1713, the dwelling originally stood on Letitia Street in the city. In 1883, it was purchased and moved to this site in West Park. When the Schuylkill Expressway was completed in the 1950s, the house became isolated until an access driveway was built in 1967. (O. S. Bunnell, c. 1908.)

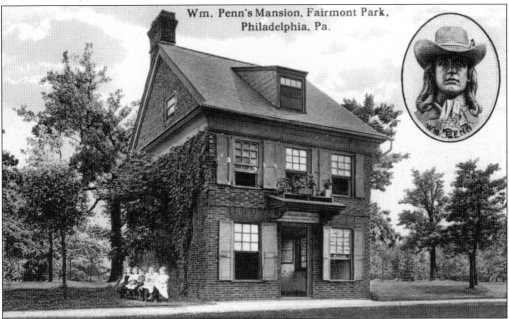

WILLIAM PENN'S MANSION. This home has often been called the Penn Mansion under the false belief that William Penn lived here. Passing through a number of owners, it served as an inn and eatery in the 1800s and later as the Woolpack Hotel. After its move to Fairmount Park, the mansion was given new life. It was restored in 1932 so that park visitors could enjoy its example of 18th-century architecture. (Post Card Distribution Company, c. 1915.)

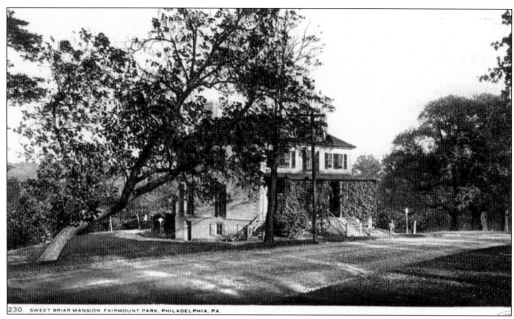

SWEET BRIAR MANSION. Overlooking the Schuylkill River, this small mansion was constructed by Congressman Samuel Breck in 1797. Here, he entertained such notables as the Marquis de Lafayette, Tallyrand, and John James Audubon. The estate became city property *c.* 1866. (Detroit Publishing Company, *c.* 1910.)

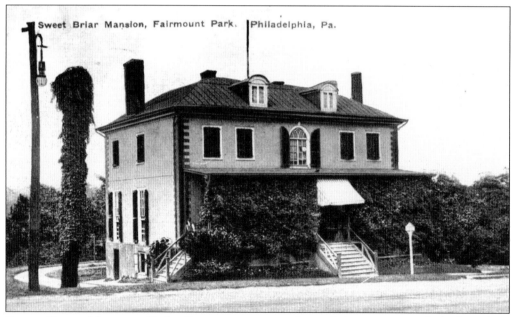

SWEET BRIAR MANSION. Built of stucco over stone, Sweet Briar Mansion includes long first-floor windows and separate outside entrances for both the kitchen and dining room. The Junior League of Philadelphia restored this five-bedroom home in 1928. It is now open for public tours. (Post Card Distribution Company, *c.* 1912.)

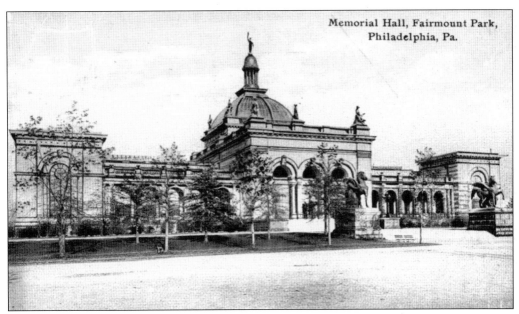

MEMORIAL HALL. Erected as a permanent building for use during the 1876 Centennial Exposition, Memorial Hall is the only major structure to survive that event. Designed by Hermann J. Schwarzmann, it took 18 months to construct. Built of iron, granite, brick, and glass, this reportedly fireproof building cost $1.5 million. Funding came from the Commonwealth of Pennsylvania and the City of Philadelphia. (Unknown, *c.* 1910.)

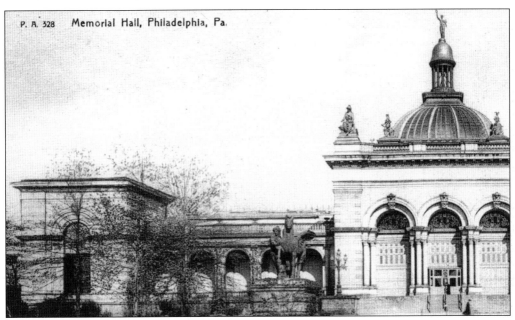

MEMORIAL HALL. Perhaps the most interesting architectural feature of this grand building, located on North Concourse Drive, is its dome. Constructed of iron and glass, it stands 150 feet above the floor of the center hall. At its top is a large zinc statue representing Columbia. Also placed on top of the building are the allegorical figures of Science, Art, Industry, and Commerce. (Rotograph Company, *c.* 1904.)

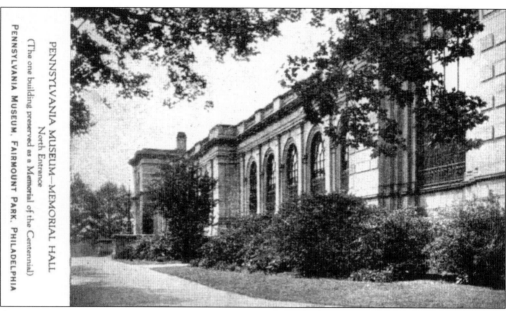

PENNSYLVANIA MUSEUM—MEMORIAL HALL. Named Memorial Hall to honor the soldiers of the Revolutionary War, the building was originally designated to serve as an art museum. By 1928, however, all major artworks had been transferred to the new museum of art. Later years saw the building used as a recreational center and as administrative offices for the Fairmount Park Commission. In 2004, the commission moved to new offices. (Pennsylvania Museum, *c.* 1904.)

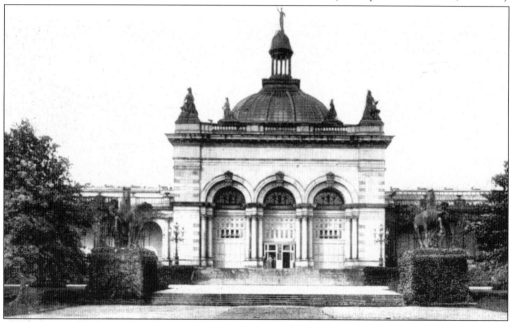

MEMORIAL HALL. The main entrance to Memorial Hall was designed with three enormous arched doorways. These are reached by climbing 13 steps, symbolizing the original colonies. Built in the Modern Renaissance style, the building measures 365 by 210 feet. When it opened, it was said to be the largest such structure in the nation and was capable of holding 8,000 people. (Leighton & Valentine, *c.* 1910.)

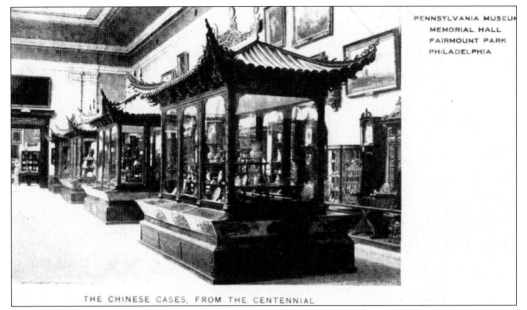

THE CHINESE CASES. This exhibit of Asian art was originally on display at the 1876 Centennial Exposition. It was one of many exhibits once housed in Memorial Hall when it served as the Pennsylvania Museum. In 1893, the Wilstach art collection was placed in the museum. By 1919, the collection had grown to more than 500 paintings, and the exhibit halls were becoming crowded with works of art. (Pennsylvania Museum, c. 1904.)

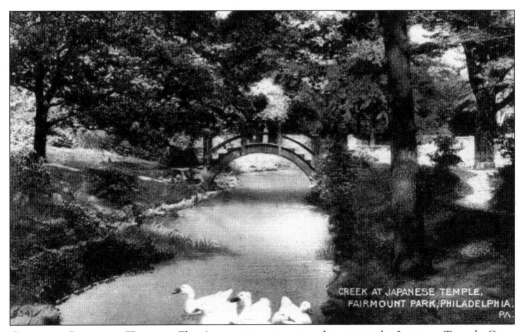

CREEK AT JAPANESE TEMPLE. Flowing next to a structure known as the Japanese Temple Gate, this small stream added ambiance to the area. The high-arched, wooden footbridge, set amongst tall shady trees, helped create a feeling of serenity. Additional nearby landscaping was arranged in the Japanese style. (Souvenir Post Card Company, c. 1910.)

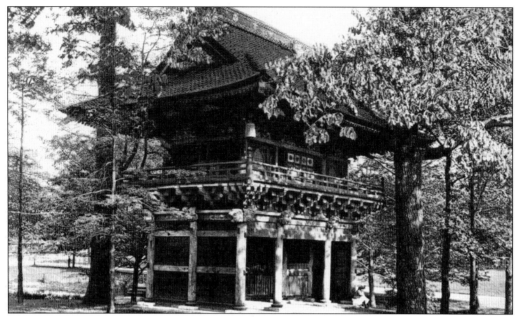

JAPANESE TEMPLE. This 300-year-old *Nio-mon* (Japanese Temple Gate) was part of an exhibit at the 1904 Louisiana Purchase Exposition in St. Louis. It was purchased by John H. Converse and Samuel J. Vaullain, who presented it as a gift to the city of Philadelphia. Moved to West Park, it was erected between Horticultural Hall and Memorial Hall in December 1905. (Unknown, *c.* 1910.)

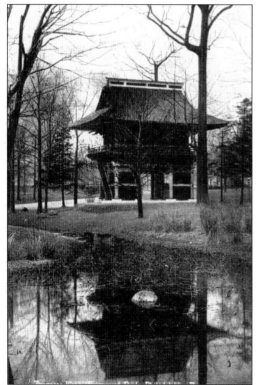

JAPANESE KIOSK. An outstanding example of Japanese craftsmanship in wood, this temple gate stood in the park for 50 years before it was destroyed by fire in 1955. In 1958, a modern version donated by the America-Japan Society replaced the lost structure. Known as the Japanese Exhibition House, the newer structure, along with its surrounding garden, is open to the public. (Leighton Company, *c.* 1909.)

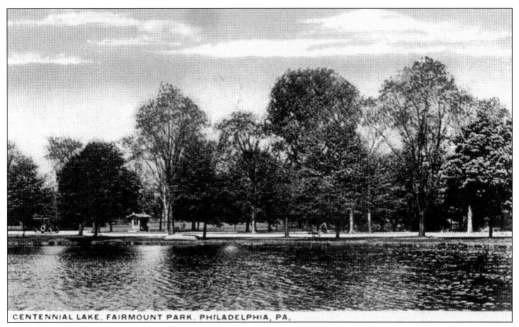

CENTENNIAL LAKE. This man-made lake derives its name from its construction for the 1876 Centennial Exposition. It is found on the west side of Belmont Avenue, about one-eighth of a mile north of the Belmont and Parkside entrance. The lake continues to serve a role in the life of the park. (Silbro, *c.* 1916.)

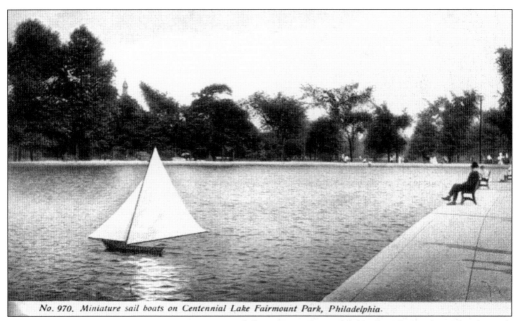

MINIATURE SAILBOATS. A man sits on a park bench set along the banks of Centennial Lake. He watches a miniature sailboat as a slight breeze propels it across the surface of the water. Relaxing by the lake was another pleasurable way to spend a sunny day in the park. (Philadelphia Post Card Company, *c.* 1909.)

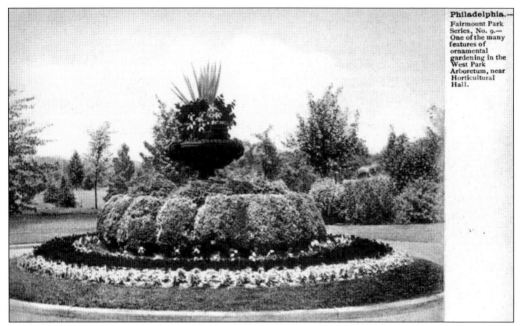

NEAR HORTICULTURAL HALL. A large urnlike planter catches the eye with its attractive floral arrangements. This was only one of many ornamental gardening features to be found near Horticultural Hall. This landscaped section of the park was referred to as the West Park Arboretum. (Stern & Company, c. 1905.)

A PICTURESQUE WALK. Walking from Memorial Hall toward Horticultural Hall along this path, one passed through the arboretum. In this region of the park, natural plant growth was supplemented by many man-made plantings, creating a horticulturist's delight. (Souvenir Post Card Company, c. 1909.)

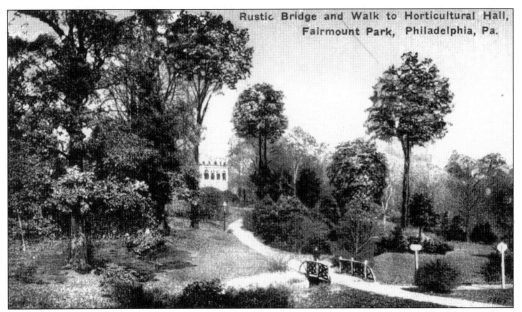

RUSTIC BRIDGE AND WALK. A man stands at the small rustic bridge over which the path continues toward the distant Horticultural Hall. From its earliest days, the Fairmount Park Commission allocated money to provide for the botanical features that have made this one of the largest landscaped public parks in the world. (Unknown, c. 1916.)

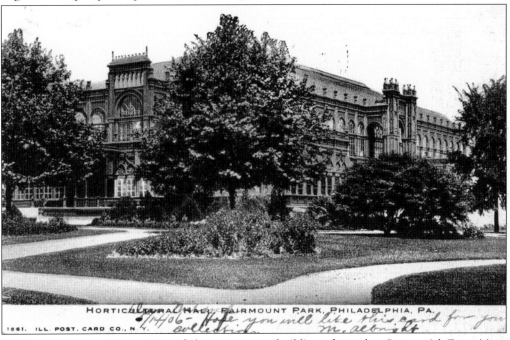

HORTICULTURAL HALL. One of the permanent buildings from the Centennial Exposition, Horticultural Hall, like Memorial Hall, was designed by Hermann J. Schwarzmann. Costing $251,937 to construct, this remarkable arboretum measured an astounding 380 feet in length and 193 feet in width. Unfortunately, this huge structure fell into disrepair and, after suffering damage from Hurricane Hazel, was demolished in 1955. (Illustrated Post Card Company, c. 1906.)

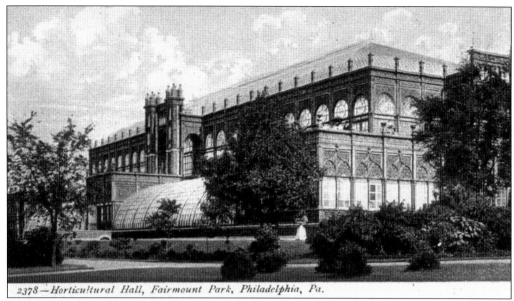

HORTICULTURAL HALL. Large, curved-glass greenhouses were located on either side of the main entranceway to Horticultural Hall. Here, hothouse plants and young seedlings could be propagated. The domed main roof of the building was also made of iron and glass. This allowed natural light to enter the major exhibit rooms, a necessary measure to meet the needs of growing plant life. (Souvenir Post Card Company, c. 1905.)

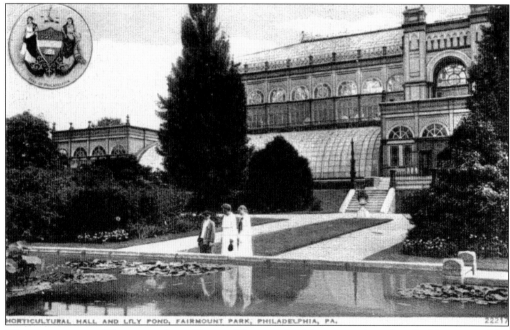

HORTICULTURAL HALL AND LILY POND. Three park visitors gaze into the placid waters of the pond near the entrance to Horticultural Hall. Once inside the building, they could inspect all manner of exotic tropical plants and fruit-bearing trees. Many of the plants on display were considered to be quite rare and valuable. (Unknown, c. 1917.)

INTERIOR HORTICULTURAL HALL.
Upon entering the great plant conservatory, the visitor would undoubtedly be struck by the unusual interior design. It was said to have been fashioned in the 12th-century Moorish style. Some of the characteristic detailing can be seen in this view of the columns and arches at the entrance to one of the exhibition rooms. (World Post Card Company, *c.* 1905.)

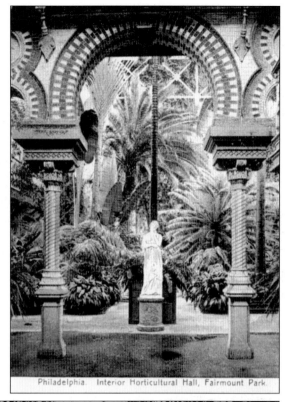

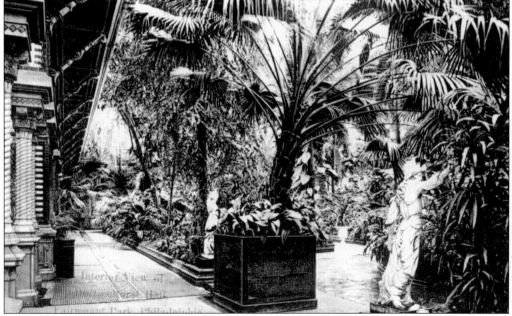

INTERIOR VIEW. Following the walkways that wove in and around the botanical exhibits, visitors could experience the wondrous world of plants. Displays featured everything from medicinal and food species to ferns, palms, cacti, and Australian flora, as well as numerous types of flowering and fruit-producing trees and shrubs. (Unknown, *c.* 1910.)

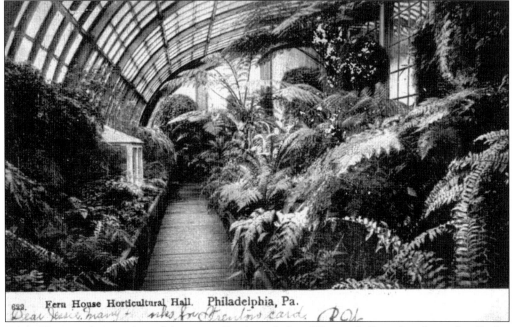

FERN HOUSE. One section of the vast collection of plant life was dedicated to ferns. On display were more than 100 species of ferns, both native and imported, along with 23 different varieties of mosses. Walking along a narrow wooden boardwalk, visitors could closely observe these plants. (Photo Art Company, c. 1907.)

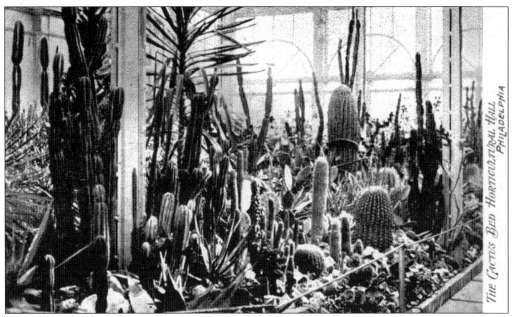

THE CACTUS BED. Besides many forms of tropical vegetation, Horticultural Hall also housed a large number of cactus plants. Quite a variety of these desert-dwelling plants can be seen arranged together in one large display. From small, ball-shaped forms to taller, columnar specimens, they coexist in the garden, making an interesting tableau. (World Post Card Company, c. 1905.)

LILY POND, SUNKEN GARDENS. Many acres of ground surrounding Horticultural Hall were landscaped so that parkgoers would be provided with floral beauty at every turn. A mixture of styles and types of gardens provided endless delights for flower lovers. With each change of season, new blooms and growths greeted those walking among the plantings. (Unknown, *c.* 1910.)

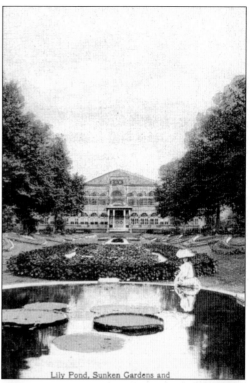

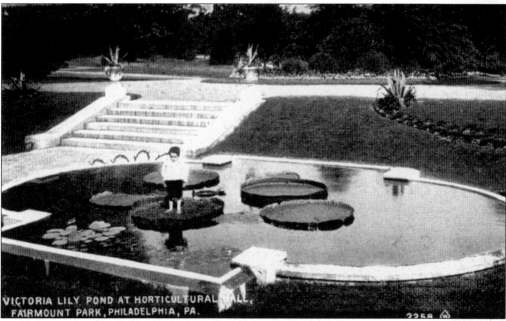

VICTORIA LILY POND. Situated behind Horticultural Hall was the Victoria Lily Pond, one of a number of water gardens established in the park. Floating on the surface of the motionless water, the leaves of these giant South American Victoria regis water lilies are capable of supporting a considerable amount of weight. The small child standing on one of these plants demonstrates this fact. (P. Sander, *c.* 1922.)

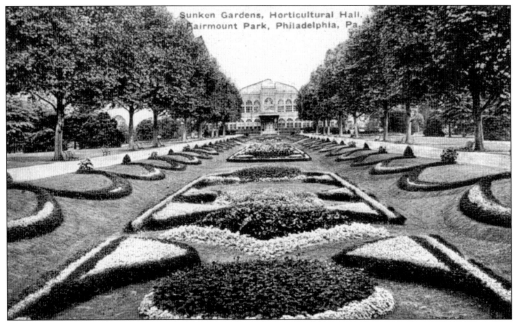

SUNKEN GARDENS. The Sunken Gardens lie within a long, rectangular expanse of depressed terrain on the west side of Horticultural Hall. Since the days of the Centennial Exposition, it has been a favorite spot for many visitors. This is especially true in the spring, when the manicured flowerbeds yield patterns of colorful blooms. (Post Card Distribution Company, c. 1910.)

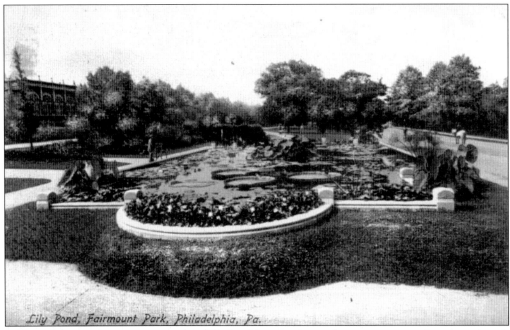

LILY POND. A large water garden filled with a variety of emergent aquatic vegetation is identified simply as the Lily Pond. Displays of this type helped add an exotic feel to the park. Surely this shallow pool, with its unusual plants, attracted the interest of any curious passerby. (Illustrated Post Card Company, c. 1906.)

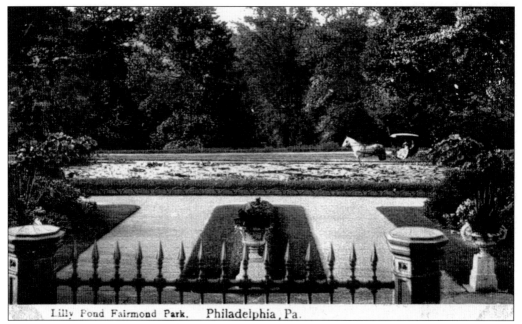

LILY POND. Decorative, plant-filled urns were placed alongside the walkway that led to the Lily Pond. A couple seated in a horse-drawn carriage, possibly spending the afternoon in the park, has stopped to enjoy the view. The park offered visitors all manner of botanical wonders. (Photo Art Company, c. 1908.)

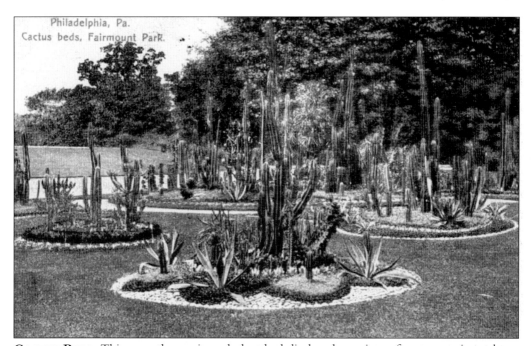

CACTUS BEDS. This expertly manicured plant bed displayed a variety of cactus species and was situated near the statue representing Religious Liberty, opposite the east entrance to Horticultural Hall. (O. S. Bunnell, c. 1908.)

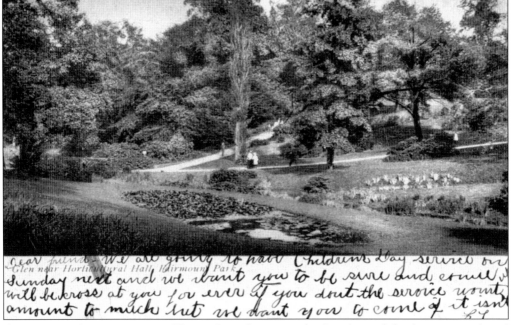

GLEN NEAR HORTICULTURAL HALL. Over the years, plantings by park landscapers continued to supplement the natural vegetation, creating charming vistas such as this. Surveys by the Academy of Natural Sciences and the Philadelphia Botanical Club have identified more than 2,000 species of plants within the park's boundaries. (Douglass Post Card Company, c. 1906.)

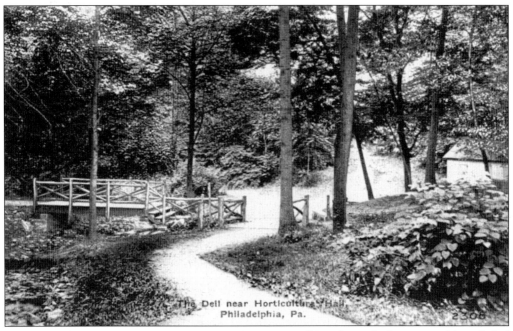

THE DELL NEAR HORTICULTURAL HALL. A person walking the path that enters this secluded hollow near Horticultural Hall was rewarded with this charming vision. Referred to as the Dell, the sylvan setting with rustic bridge could easily serve as an artist's inspiration. (Unknown, c. 1910.)

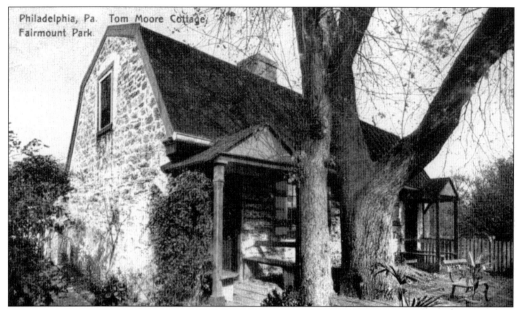

TOM MOORE COTTAGE. Built c. 1805, this stone cottage somehow became associated with Irish poet Thomas Moore (1779–1852). It is highly unlikely he ever occupied the house when he visited Philadelphia in 1804. Located north of the Columbia Avenue Bridge, the home has had many names, including the Pig Eye Cottage, Aunt Cornelia's Cottage, and Belmont Cottage. The building later became the headquarters for the park's mounted police. (Unknown, c. 1908.)

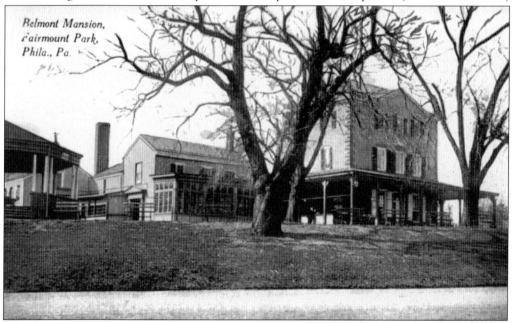

BELMONT MANSION. Originally part of a large estate of 442 acres, this mansion has seen many changes over the years. The main house of brick and rubble was built in 1755 by Hon. William Peters in the Palladian style and stood two stories high. Another owner added a third floor in 1853. The home is noted for its ornamental plastered ceiling, reportedly the first of its kind in this country. (Unknown, c. 1910.)

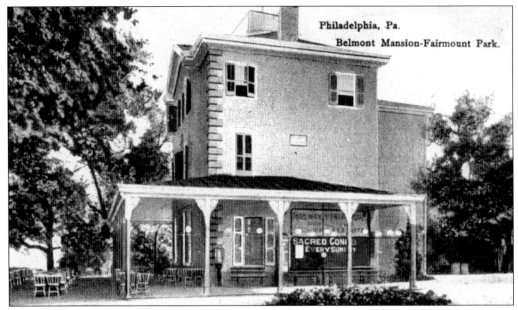

BELMONT MANSION. During the ownership of Hon. William Peters, the mansion was the scene of many social events and dinner parties. Such famous individuals as George Washington, Benjamin Franklin, and James Madison were often guests here. Later years saw the location serve as a café and restaurant. The home has since been restored and is now open for public tours. (Unknown, c. 1909.)

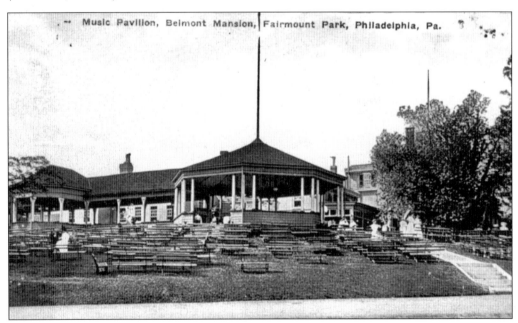

MUSIC PAVILION. Situated behind the Belmont Mansion, this music pavilion provided a location for music lovers to enjoy outdoor concerts. For a number of years, the 40-piece Fairmount Park Band performed here every Wednesday and Saturday evening. These concerts attracted large numbers of people. Similar music pavilions were located at Strawberry Hill, Lemon Hill, and George's Hill. (Unknown, c. 1910.)

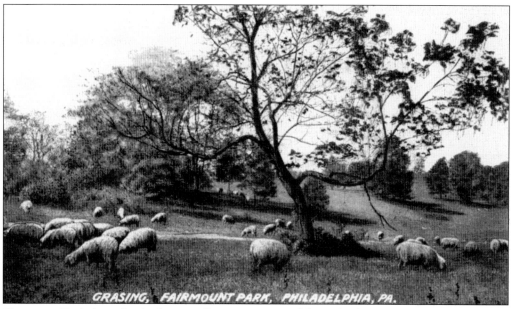

GRASING. To help maintain the sprawling grassy areas of the park, the commission experimented with grazing flocks of sheep. The sheep were especially used along Chamounix Drive, and a sheep fold was built about 250 yards north of the Belmont Park trolley station. Although they created a pleasant pastoral scene, the sheep were not particularly successful in controlling the growth of the lawns. (Unknown, c. 1910.)

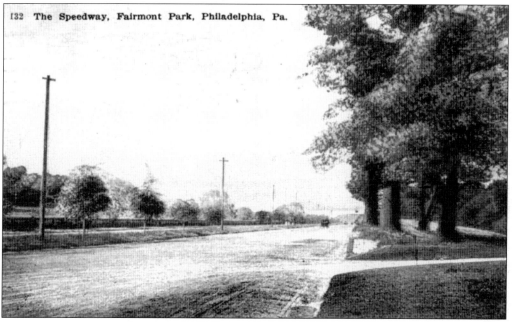

THE SPEEDWAY. Regulations during the early 1900s prohibited speeds in excess of seven miles per hour on park roads. The exception was here on the Speedway, which was situated along Chamounix Drive near its junction with Belmont Avenue. Fast driving was allowed only in the northeastern direction. Return travel was again subject to the seven-miles-per-hour rule. (Unknown, c. 1911.)

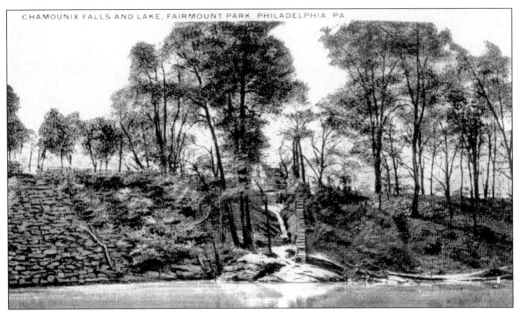

CHAMOUNIX FALLS AND LAKE. A distant waterfall feeds into Chamounix Lake. This lake was easily accessible to park visitors, as it was located near the Chamounix Park trolley station. A popular recreational area during the 1900s, it unfortunately no longer exists. (Unknown, *c.* 1918.)

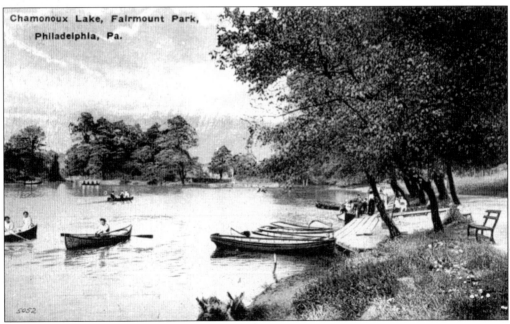

CHAMONOUX LAKE. At this small boat landing under the shade of the trees, canoes and rowboats could be rented. A row or paddle on the still, open water of the lake was a pleasurable escape for city dwellers visiting the park for the day. (Unknown, *c.* 1918.)

No. 973. Chamonioux Lake Fairmount Park, Philadelphia.

CHAMONIOUX LAKE. A young family enjoys a day of boating on Chamounix Lake. Such leisurely activity was very popular with parkgoers. During the early 1900s, just as today, the lure of the park's recreational possibilities attracted large numbers of visitors on weekends and holidays. (Philadelphia Post Card Company, c. 1910.)

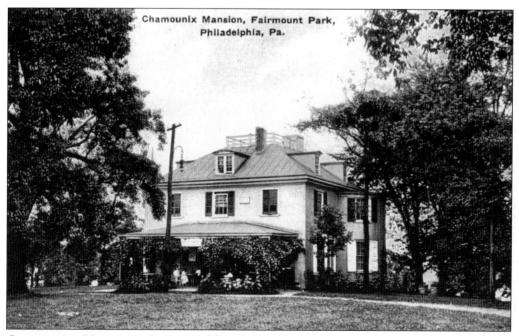

CHAMOUNIX MANSION. Constructed by George Plumstead in 1802 just a mile north of the Belmont Mansion, this Federal-style home offers a panoramic view of the city. In 1964, after restoration, the building became the first international youth hostel of any city in the country. Today, it welcomes people from around the world. (Unknown, c. 1909.)

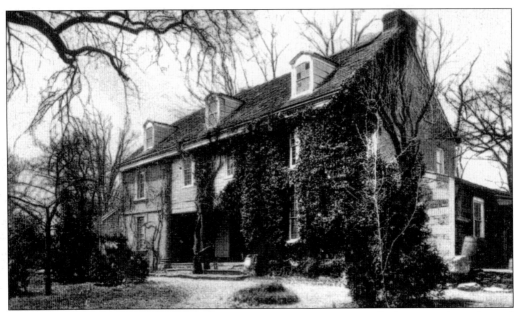

BARTRAM'S HOUSE. In 1728, John Bartram (1699–1777), America's first great botanist and naturalist, purchased this stone home and 27-acre estate. Here, he established the nation's first botanical garden with plant specimens gathered from locations throughout North America and Europe. Located at 54th Street and Lindbergh Boulevard, the house and gardens are open to the public. (American News Company, c. 1906.)

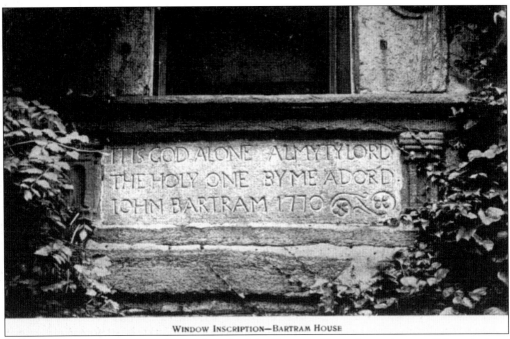

WINDOW INSCRIPTION. On the south end of the Bartram House beneath one of the windows is a polished stone inscribed by John Bartram in 1770. A confession of his religious belief, it reads, "It is God alone, Almighty Lord, the Holy One, by me ador'd." (Bartram Association, c. 1908.)

Four
THE ZOOLOGICAL GARDEN

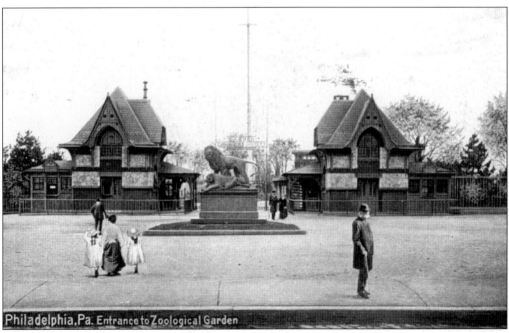

ENTRANCE TO ZOOLOGICAL GARDEN. The Philadelphia Zoological Garden, situated on 42 acres of land on the west bank of the Schuylkill River, was opened to the public on July 1, 1874. At its opening, 282 animals and 674 birds were on exhibit. Included among them was Atlanta, the cow that accompanied General Sherman on his famous march through Georgia. (H. C. Leighton Company, *c.* 1909.)

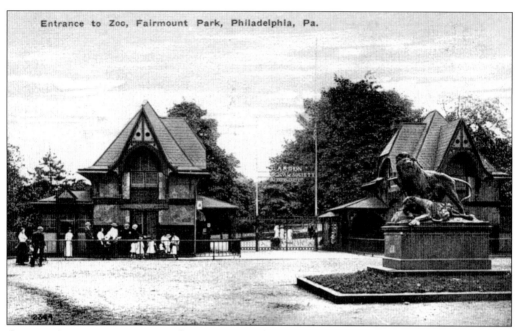

GIRARD AVENUE ENTRANCE. The Victorian-style entrance buildings, erected between 1873 and 1875, were designed by architects Frank Furness and George Hewitt. The 1874 opening day drew more than 3,000 visitors who paid an admittance fee of 25¢ for adults and 10¢ for children. This cost of entry remained the same for the next 50 years. (Souvenir Post Card Company, c. 1909.)

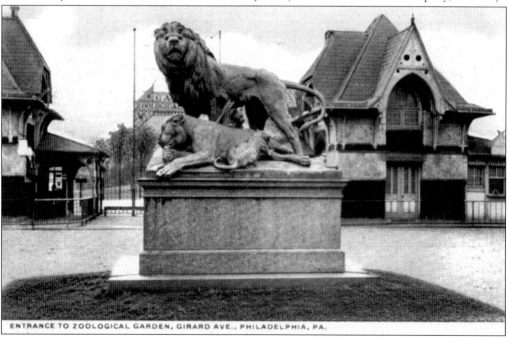

ENTRANCE TO ZOOLOGICAL GARDEN. This splendid bronze sculpture standing at the main gate has greeted visitors to the zoo since 1876. Titled *Dying Lioness*, this statue was purchased by the Fairmount Park Art Association. The highly realistic renderings of two lions are the work of the German sculptor Wilhelm Wolff. (Post Card Distribution Company, c. 1914.)

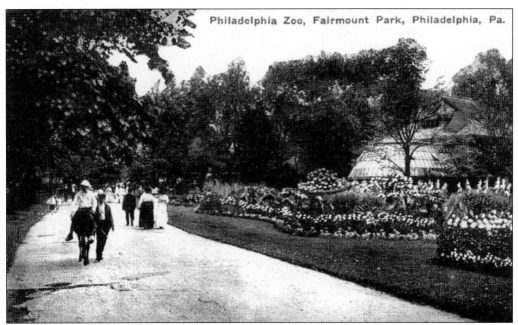

PHILADELPHIA ZOO. The design and layout of the Philadelphia Zoological Garden was the work of Herman J. Schwarzmann. He was also the man who designed Horticultural and Memorial Halls. Walkways were laid out so as to ensure easy access to the numerous animal houses and enclosures. (S. M. Company, *c.* 1910.)

ZOOLOGICAL GARDENS. The zoo was not only a place to see collections of animals but also to observe a rich variety of flora. Hundreds of representative species of exotic and native plants were displayed in numerous Victorian-style gardens placed throughout the grounds. These gardens are near the Carnivore House. (Unknown, *c.* 1910.)

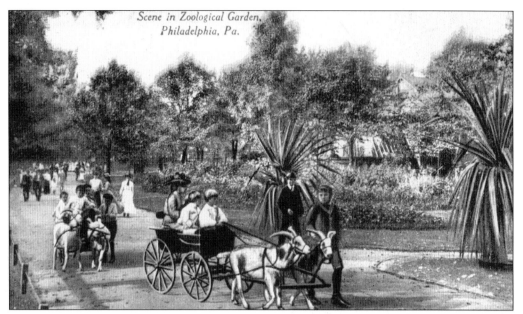

SCENE IN ZOOLOGICAL GARDEN. Since its opening, the zoo has been a popular attraction. During the early 1900s, goat carts such as these could be hired to transport children along the pathways. This was surely a fun way to enjoy the day and make the visit a memorable one. Even today, the zoo is the leading family attraction in Philadelphia and draws more than one million visitors a year. (Unknown, c. 1910.)

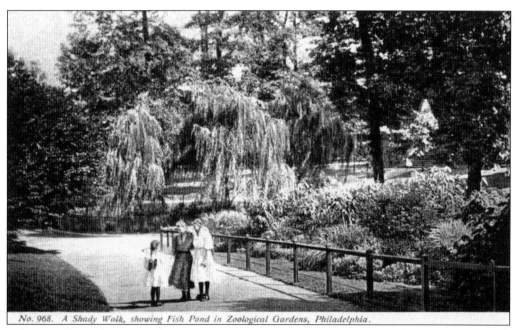

A SHADY WALK. Walkways in the park, protected by a variety of native and foreign tree species, were comparatively dry in wet weather. The shade from these trees also could provide welcome relief from the hot sun during summer visits. Here, three girls pause on a walkway near one of several small ponds on the zoo grounds. (Philadelphia Post Card Company, c. 1910.)

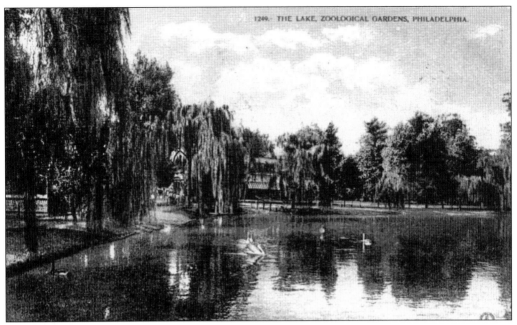

THE LAKE. Located near the center of the zoo was a body of water simply known as "the Lake." This area was occupied by waterfowl species from around the world. Included among them were many varieties of swans, geese, and ducks. The Lake provided visitors a charming and tranquil scene to enjoy as they strolled along the walkways. (Osborne Post Card Company, c. 1906.)

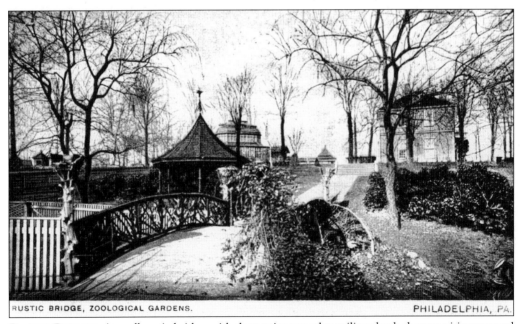

RUSTIC BRIDGE. A small rustic bridge with decorative wooden railings leads the zoo visitor toward a small gazebo. Here, in the shelter of the gazebo, a person tired from walking the grounds could pause and rest or just sit and enjoy the surroundings. (Philadelphia Post Card Company, c. 1905.)

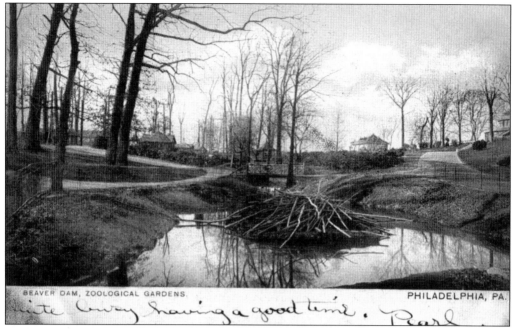

BEAVER DAM. The zoo exhibited not only exotic species from around the world but also many representative species native to North America. Among those on display was a small group of beavers. This beaver dam was constructed from saplings and small branches gathered by the animals. Dams such as this can reach heights of four feet. (Philadelphia Post Card Company, *c.* 1905.)

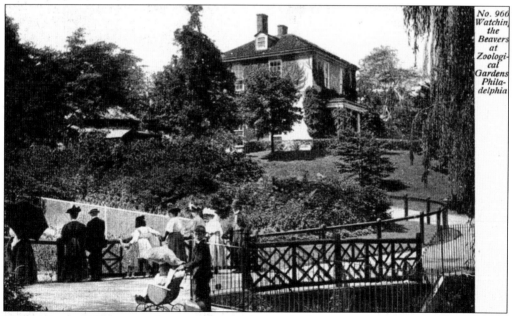

WATCHING THE BEAVERS. A group stops to observe the beavers in their enclosure, constructed to mimic their natural habitat. Standing on the hill behind them is the onetime residence of John Penn, on whose estate the zoo is now located. John was the grandson of Pennsylvania's founder, William Penn. (Philadelphia Post Card Company, *c.* 1908.)

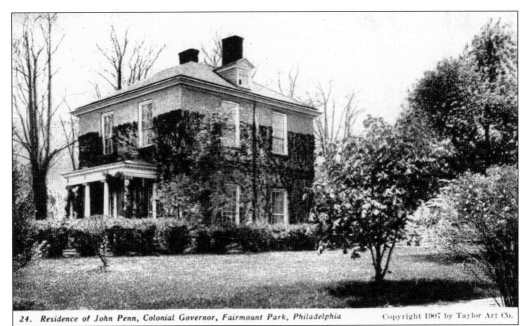

24. Residence of John Penn, Colonial Governor, Fairmount Park, Philadelphia — Copyright 1907 by Taylor Art Co.

RESIDENCE OF JOHN PENN. John Penn designed and built his home, which he named Solitude, in 1784. The house stands two and a half stories high and measures 29 by 29 feet. Acquired by the park commission in 1867, the home has been used for many purposes over the years. At one time, it served as the reptile house and later as the zoo's administration building. (Taylor Art Company, 1907.)

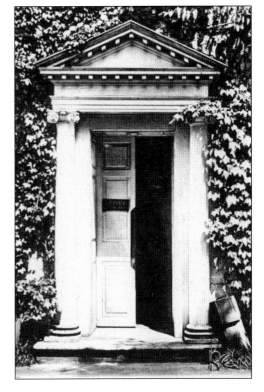

SOLITUDE. Solitude (its doorway seen here) is the only remaining original residence of a Penn family member in the country. Built in the Federal style, the house has exterior stone walls plastered over with stucco, which has been scored to give the appearance of limestone. (Architectural Post Card Company, c. 1915.)

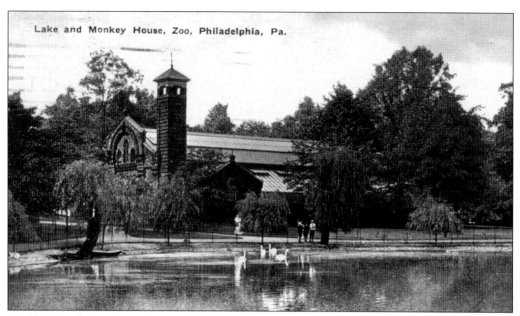

LAKE AND MONKEY HOUSE. Viewed across the Lake is the monkey house, designed by Theophilius P. Chandler. At the time of this postcard, the primate collection included an extensive grouping of monkeys and an "unusually large chimpanzee," along with two rare gibbons. In 1928, the zoo became the first in the country to have an orangutan and chimpanzee born in captivity. (Post Card Distribution Company, c. 1913.)

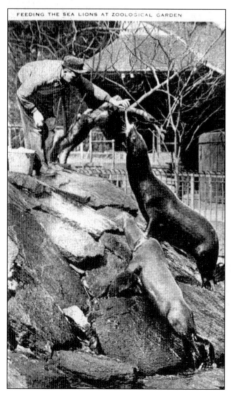

FEEDING THE SEA LIONS. A source of constant entertainment for zoo visitors, especially at feeding time, are the California sea lions. These animals are generally active, swimming, diving, climbing, and moving about their enclosure. They often draw onlookers with their loud, barking vocalizations, which can be heard from quite a distance away. (Photo Art Company, c. 1920.)

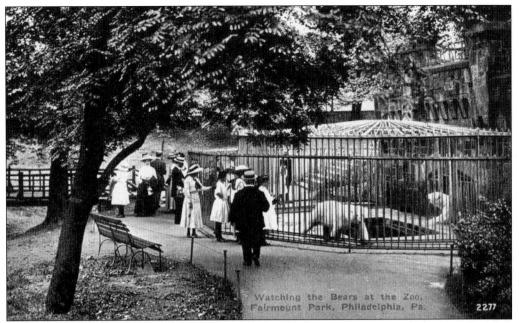

WATCHING THE BEARS. A polar bear draws the attention of a small gathering of people standing at the bear dens. During the early part of the 20th century, the zoo featured two "magnificent specimens" of Alaskan brown bear, as well as five grizzly bears captured in the Rocky Mountains. Of course, they also had the pair of polar bears seen here. (Unknown, c. 1910.)

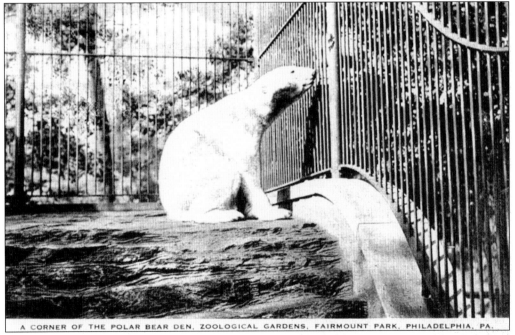

CORNER OF THE POLAR BEAR DEN. A large polar bear sits behind its iron-barred enclosure. Polar bears are said to be the most active and playful of the bear species when in captivity. They can often be seen in their water pool—not surprising, since they often swim in their natural habitat. (Photo Art Company, c. 1920.)

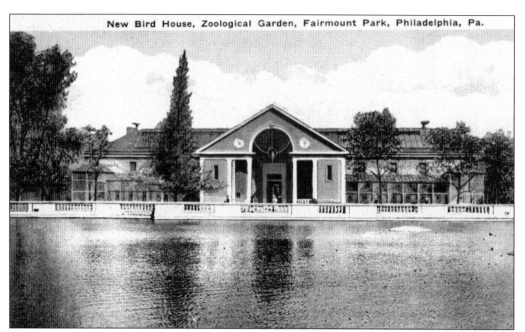

NEW BIRD HOUSE. Costing $60,000 to construct, this new bird house was opened to the public on October 3, 1916. Designed by architects Mellor and Meigs, the building was 142 feet long and 78 feet wide. Containing 16 outdoor cages, the structure could expand to include another 16 when necessary. (P. Sander, *c.* 1917.)

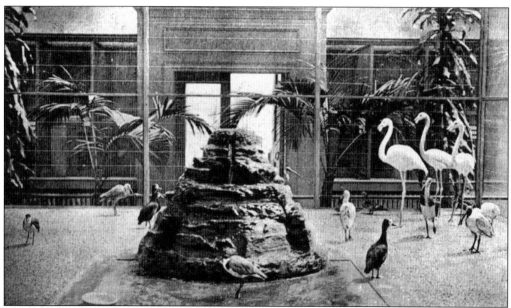

INTERIOR OF FLYING CAGE. Inside the bird house was an enormous indoor flying cage. This cage measured 29 feet long, 18 feet wide, and 20 feet high. A variety of birds, both native and exotic, were placed within this centrally located enclosure. The building also housed an additional 97 indoor cages for exhibiting bird species from around the world. (Photo Art Company, *c.* 1920.)

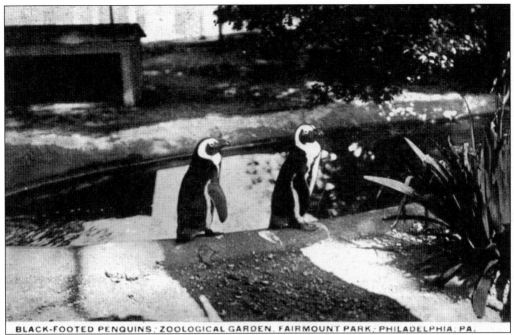

BLACK-FOOTED PENGUINS, ZOOLOGICAL GARDEN, FAIRMOUNT PARK, PHILADELPHIA, PA.

BLACK-FOOTED PENGUINS. Considered by many to be the most comical of birds, penguins always seem to attract attention. Here, two black-footed penguins stand beside their water pool. One of 17 species of penguins, they are the only ones native to Africa. Awkward on land, they are fast and graceful in the water. This species is nicknamed the "jackass penguin" because of the loud, donkey-like braying noise the animals produce. (Photo Art Company, *c.* 1919.)

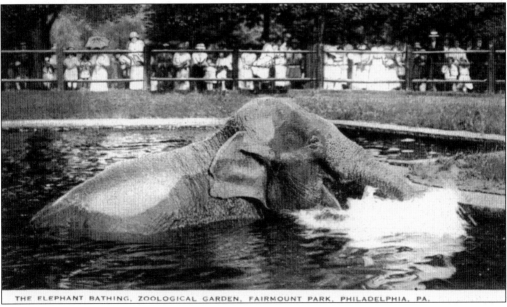

THE ELEPHANT BATHING, ZOOLOGICAL GARDEN, FAIRMOUNT PARK, PHILADELPHIA, PA.

ELEPHANT BATHING. The elephants are a favorite of many zoo visitors, and this one proves to be no exception. A crowd of spectators looks on as the animal cools off by frolicking in the pool immediately adjoining the elephant house. This particular elephant is an Indian female named Kaiserin, presented to the zoo in 1902. (Photo Art Company, *c.* 1920.)

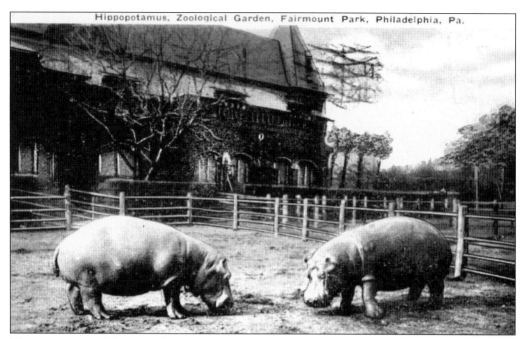

HIPPOPOTAMUS. These two hippopotamuses on display were received from German East Africa in 1912. These animals are native to Africa and normally live by lakes, rivers, and swamps, where they spend much of the day in the water. Like other exhibits at the zoo, this one was accompanied by a sign identifying the animal by its common and scientific name and stating its natural habitat. (P. Sander, *c.* 1916.)

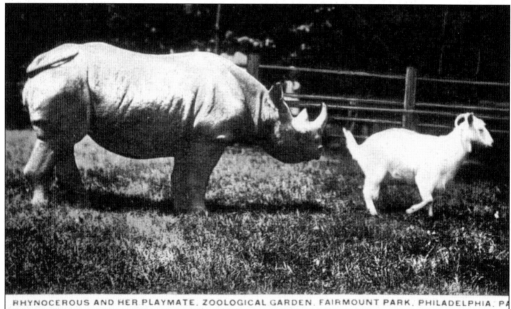

RHYNOCEROUS AND HER PLAYMATE. Largest of the land animals other than the elephants, the African rhinoceros shown here resided in the elephant house. Also sheltered here were a pair of hippopotamuses and a Malayan tapir. The zookeeper provided a goat to act as a "playmate" for the rhinoceros. (Photo Art Company, *c.* 1919.)

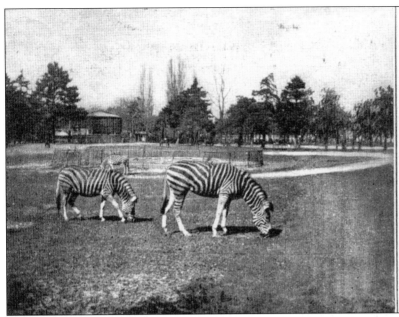

ZEBRA. Two grazing zebras are captured in this postcard view. Attractively striped members of the horse family, zebras are native to Africa. Three separate species exist, each with its distinctive pattern of stripes. These particular individuals are specimens of Burchell's zebra, captured in South Africa. (Independent Photo-Card Company, *c.* 1905.)

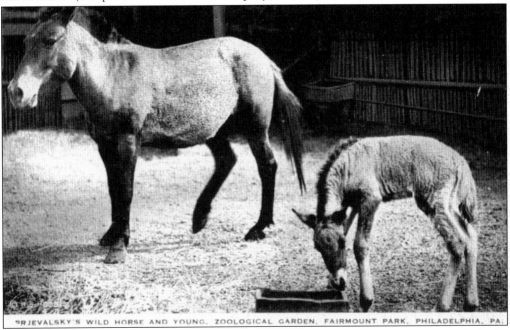

PRJEVALSKY'S WILD HORSE AND YOUNG. A rare Przewalski wild horse, named for its discoverer Nicholas Prjevalsky, stands beside its foal. The only true species of wild horse, these animals are native to Mongolia but are now extinct in the wild. Hardy creatures, they are characterized by small bodies and stiff, erect manes. Starting in 1992, captive bred animals have been released back into their former native habitats. (Photo Art Company, *c.* 1920.)

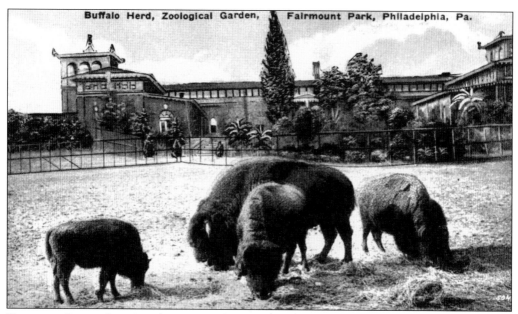

BUFFALO HERD. American bison peacefully graze in their pen. Largest of all North American hoofed mammals, they once roamed the western plains in herds sometimes numbering into the millions. Almost driven into extinction, they were still a relatively rare species when this postcard was published. In 1908, the estimated number of bison in North America was only 1,917. (Unknown, *c.* 1910.)

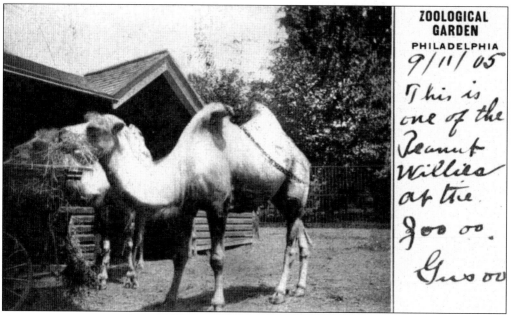

CAMEL. A small facility in terms of land area, the Philadelphia Zoological Garden has nevertheless strived to exhibit representative species of all the major reptile, bird, and mammal groups. Here, two Bactrian camels calmly feed from a cart. Native to Central Asia, these animals were commonly used as beasts of burden, capable of carrying loads of up to 500 pounds. (Independent Photo-Card Company, *c.* 1905.)

Five
THE WISSAHICKON VALLEY

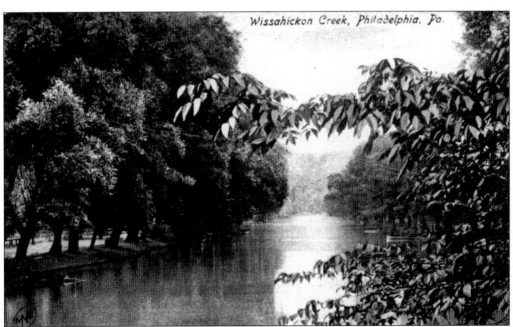

WISSAHICKON CREEK. The 21-mile-long Wissahickon Creek derives its name from the Lenni Lenapi names Wissauchsickun, meaning "yellow-colored stream," and Wisamican, meaning "catfish creek." The Wissahickon's last seven miles pass through a region known as the Wissahickon Valley before joining the Schuylkill River. This view captures a short stretch of the creek passing through Fairmount Park. (Metropolitan News Company, c. 1906.)

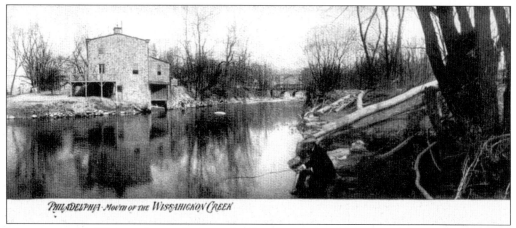

MOUTH OF THE WISSAHICKON CREEK. The flowing waters of the Wissahickon Creek end here at the junction with the Schuylkill River. On the far bank of the creek is an old mill building belonging to the Philadelphia Canoe Club, which was established in 1905. Following the waterway back upstream, past the railroad bridge seen in the distance, one enters the Wissahickon Valley. (World Post Card Company, c. 1905.)

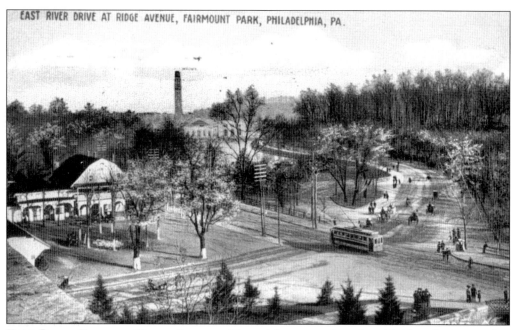

EAST RIVER DRIVE AT RIDGE AVENUE. Viewed from atop the railroad bridge, the intersection of East River (Kelly) Drive, Ridge Avenue, and Wissahickon Drive (since renamed Lincoln Drive) looks much different than it does today. The trolley car on Ridge Avenue is likely heading to Manayunk. Visible in the distance is Gustine Lake. (Post Card Distribution Company, c. 1910.)

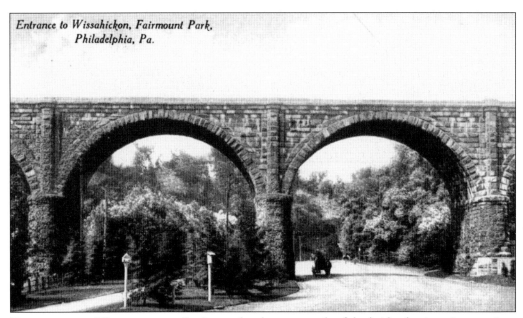

ENTRANCE TO WISSAHICKON. Passing under the stone arch of the bridge begins a journey into the lower Wissahickon Valley. Here, off Ridge Avenue, Wissahickon (Lincoln) Drive originates and continues, tracing a path along a portion of the Wissahickon Creek. The Wissahickon Valley, with its rugged topography and rich history, was incorporated into Fairmount Park in 1868. (Unknown, *c.* 1910.)

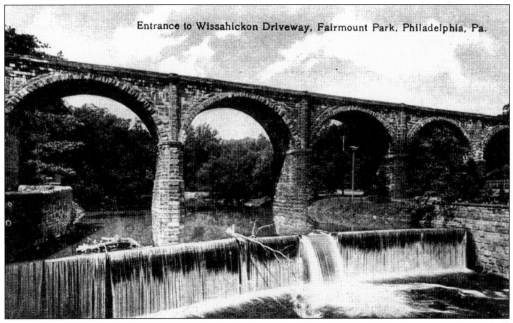

ENTRANCE TO WISSAHICKON DRIVEWAY. Just upstream, a short distance from where the Wissahickon Creek meets the Schuylkill River, is the first of many beautiful falls that exist along this waterway. The water spilling over the dam, with the railroad bridge behind it, has been a popular subject for postcard views published over the years. (Post Card Distribution Company, *c.* 1910.)

PHILADELPHIA & READING RAILROAD BRIDGE. Standing at the Ridge Avenue entrance to the Wissahickon is the Philadelphia & Reading Railroad Bridge, now part of the Septa Regional Rail System. A stone bridge with multiple arches, it is reminiscent in design to the old Roman aqueducts. (Leighton & Valentine, c. 1910.)

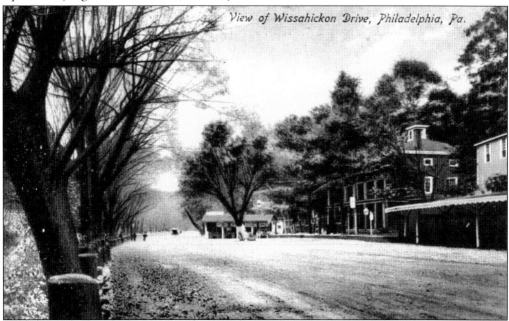

VIEW OF WISSAHICKON DRIVE. Wissahickon (Lincoln) Drive heads northeast along the Wissahickon Creek. This view, just south of Gypsy Lane, shows Wissahickon Hall, which was built in 1849. This was one of seven roadside taverns and inns that once served the Wissahickon area. In later years, the building became one of the headquarters of the Fairmount Park Guard. (Illustrated Post Card Company, c. 1908.)

![Log Cabin Picnic Grounds and Wissahickon Creek, Fairmount Park, Phila., Pa.]

LOG CABIN PICNIC GROUNDS. A little farther north on Wissahickon (Lincoln) Drive is the location of the former Log Cabin Inn. The area incorporated picnic grounds and a place to rent small boats and canoes. In the distance is the Hermits Lane Bridge. (Illustrated Post Card Company, c. 1908.)

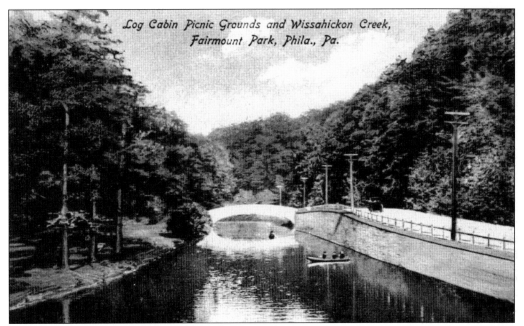

HERMITS LANE BRIDGE. This bridge's name originates from the legend of Johannes Kelpius, a religious hermit who lived in a cave nearby. He and his followers established a religious sect known as the Tabernacle of the Mystic Brotherhood. Upon his death in 1708, Kelpius's last desire to be sealed in a casket and cast into the Schuylkill River was fulfilled. (Post Card Distribution Company, c. 1912.)

HERMITS LANE BRIDGE. Situated at Hermits Lane and Wissahickon (Lincoln) Drive below Rittenhouse Street, this arched stone bridge presents a charming scene as rowers pass along the creek. Near the bridge, on the west side of the stream, is a path that leads to Lovers Leap. (P. Sander, *c.* 1920.)

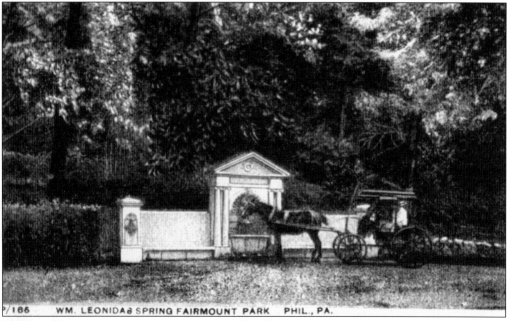

WILLIAM LEONIDAS SPRING. On the east side of Wissahickon Creek, near the Hermits Lane Bridge, is the William Leonidas Spring. Fed by a natural spring, this fountain and trough furnished cool drinking water for people and horses alike. According to a 1913 Fairmount Park guidebook, this was but one of 19 such public water sources located within the Wissahickon area. (Unknown, *c.* 1916.)

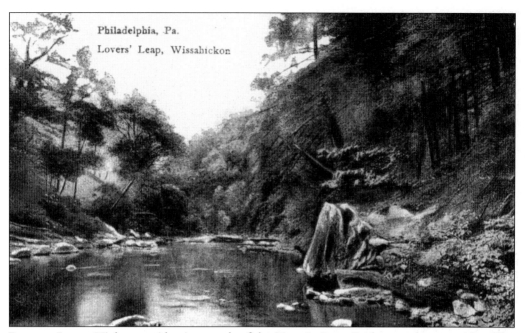

LOVERS LEAP. High on a ridge just north of the Hermits Lane Bridge, on the west side of the creek, is an overhanging cliff that has been given the name Lovers Leap. Legend states that a young Native American maiden and her warrior lover jumped to their deaths from the precipice. The famed rock is located up on the hillside to the right of this view. (Unknown, *c.* 1910.)

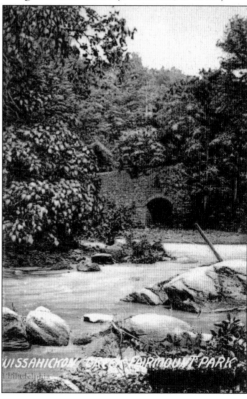

WISSAHICKON CREEK. About a mile and a half north of Ridge Avenue is an old stone bridge known as the Rittenhouse Bridge. Here starts Forbidden Drive, a gravel road that heads north for a little over five miles following the Wissahickon Creek. A regulation bans all vehicular traffic from using it, hence its name. This ban is celebrated every year in April during the Wissahickon Day parade. (Unknown, *c.* 1904.)

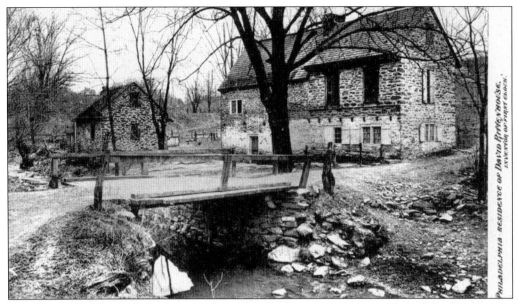

RESIDENCE OF DAVID RITTENHOUSE. The first paper mill in the new world, Rittenhouse Mill, was located here along the banks of the Wissahickon. In this stone house, David Rittenhouse (1732–1796), grandson of the mill's operator, was born. David was a noted mathematician, astronomer, surveyor, and clockmaker during the Colonial era. (World Post Card Company, c. 1908.)

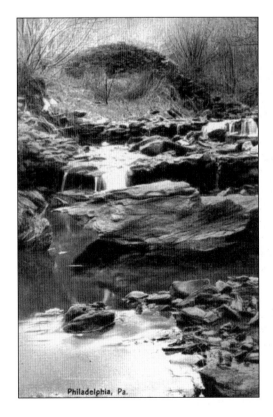

SITE OF RITTENHOUSE PAPER MILL. Mills of all types (grist, saw, paper, or textile) required a source of flowing water to provide power. The Rittenhouse Mill, built by William Rittenhouse, was no exception. Here, along the shores of the Wissahickon, are the ruins of these operations, which date back to 1690. (O. S. Bunnell, c. 1908.)

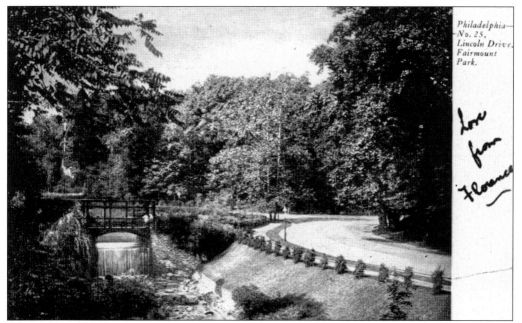

LINCOLN DRIVE. Meandering along, following the stream known as Paper Mill Run, Lincoln Drive makes its way northeast toward Harvey Street. The water traveling down this watercourse feeds into the Wissahickon Creek at the lower entrance to Forbidden Drive. (Unknown, c. 1908.)

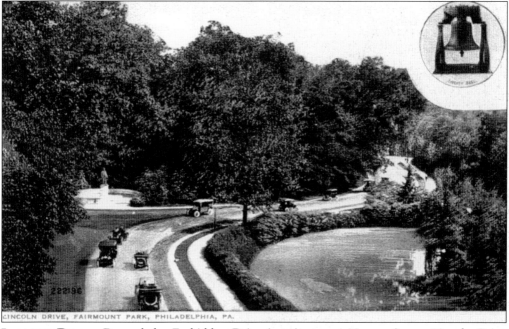

LINCOLN DRIVE. Beyond the Forbidden Drive junction, near Harvey Street, Lincoln Drive passes the Upper and Lower Lincoln Lakes. Seen to the left is a statue by J. Massey Rhind that pays tribute to Henry H. Houston. Houston, the owner of the Wissahickon Inn, donated a considerable amount of land to the park system. (Unknown, c. 1915.)

ENTRANCE TO FAIRMOUNT PARK. A member of the Fairmount Park Guard stands in the ivy-covered walkway entrance at Johnson Street. This is located at the northeastern end of Wissahickon (Lincoln) Drive. The Fairmount Park Guard was formed in 1868 to patrol and enforce park regulations. In 1972, the group formally merged with the city's police department, becoming the Fairmount Park Police. (Unknown, c. 1910.)

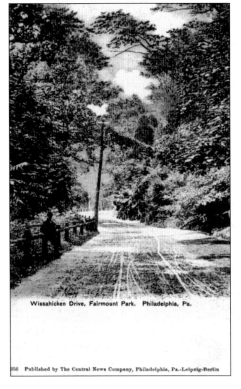

WISSAHICKON DRIVE. At the location where the Cresheim Creek flows into the Wissahickon begins the section of roadway known as the Upper Wissahickon or Forbidden Drive. Carriage tracks are visible in the gravel surface of the road, which follows the creek northward through the shady forest. The road extends from Lincoln Drive to Northwestern Avenue. (Central News Company, c. 1906.)

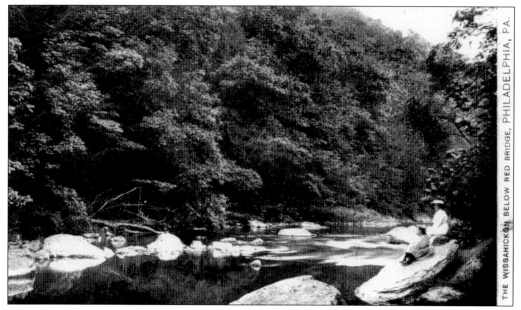

THE WISSAHICKON BELOW RED BRIDGE. Along Forbidden Drive, two young ladies sit on a rock at the creek, enjoying the aesthetic scenery. It is almost hard to imagine that such a location could exist so close to the center of a large city. This secluded spot is situated below the site of the former Red Bridge, which has since been replaced by the Blue Stone Bridge. (Unknown, c. 1907.)

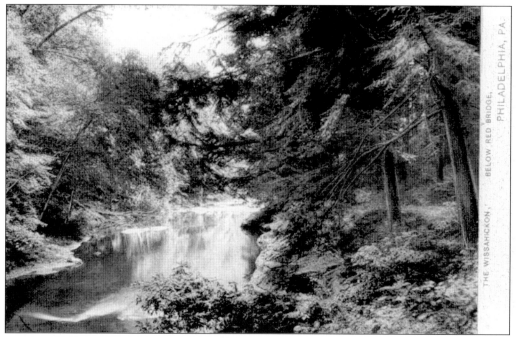

BELOW RED BRIDGE. This view shows the Wissahickon Creek as it flows downstream below the site of the former Red Bridge. Scenes such as this have inspired poets and painters over the decades and have provided endless delights for hikers and horseback riders as they travel through the park. (Unknown, c. 1908.)

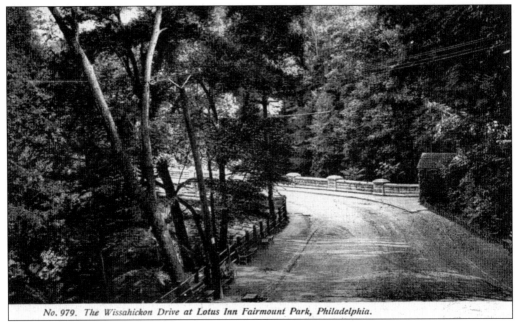

No. 979. The Wissahickon Drive at Lotus Inn Fairmount Park, Philadelphia.

WISSAHICKON DRIVE AT LOTUS INN. Seen here is the treelined approach to the Blue Stone Bridge. This bridge has also been referred to as the Lotus Inn Bridge, in recognition of the nearby Lotus Inn. The inn, like most of the other Wissahickon roadhouses, was known for serving up the local culinary favorite: catfish and waffles. (Philadelphia Post Card Company, c. 1908.)

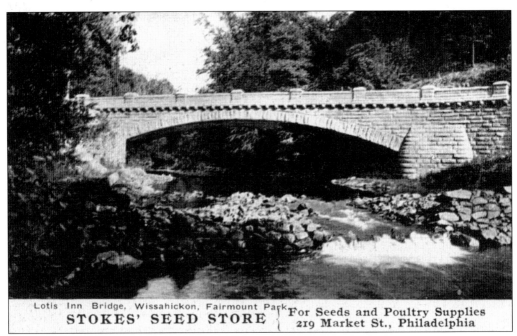

Lotis Inn Bridge, Wissahickon, Fairmount Park
STOKES' SEED STORE For Seeds and Poultry Supplies
219 Market St., Philadelphia

LOTUS INN BRIDGE. A short distance below Walnut Lane stands the Blue Stone (Lotus Inn) Bridge. Built in the late 1890s, it replaced the well-known Old Red Bridge, a wooden covered bridge that had spanned the creek. Here, water cascades over the remains of an old dam just below the bridge. (Goggins, c. 1904.)

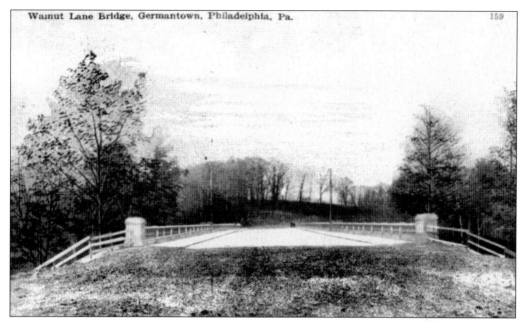

WALNUT LANE BRIDGE. Viewed from Walnut Lane is one of the 53-foot-wide approaches to the Walnut Lane Bridge. Prior to the completion of this span, the Wissahickon gorge effectively separated the communities of Germantown and Roxborough. Its opening had a profound effect on the lives of the people in these two sections of Philadelphia. (Unknown, c. 1908.)

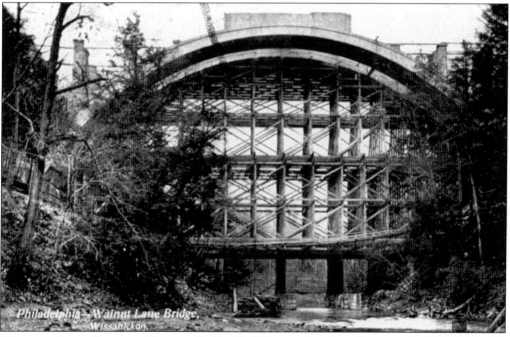

WALNUT LANE BRIDGE. Here, the bridge-building project is under way. On December 27, 1907, when construction was almost complete, the wooden scaffolding under the center arch collapsed, sending workers plummeting to the creek below. One man was killed and two seriously injured in the accident. (World Post Card Company, c. 1906.)

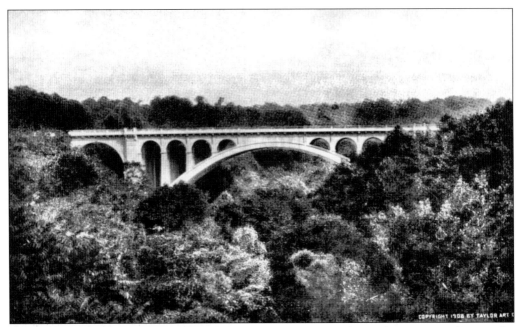

WALNUT LANE BRIDGE. At the time of its dedication in 1906, the Walnut Lane Bridge was the world's longest concrete bridge. Using 40,000 tons of cement, it was a monument to the "cement age." This grand structure was designed by George M. Heller, while its chief engineer, George S. Webster, and the contractors Reilly & Riddle saw it to completion. The cost of the project was approximately $260,000. (Taylor Art Company, 1908.)

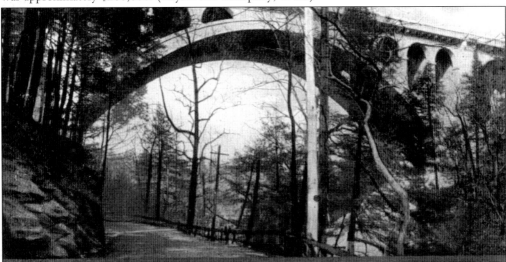

Philadelphia—The concrete bridge over the beautiful Wissahickon Creek and Driveway. This view shows but one of the five great spans of solid concrete work of the second largest bridge of its kind in the world. In the construction of this marvel of latter day engineering no less than 40,000 tons of cement were used. The total length of the bridge is 585 feet and the main span measures 233 feet in the clear and has a rise of 70 feet, 6 inches. The cost of the bridge exceeded $260,000.

THE CONCRETE BRIDGE. A genuine engineering marvel of its day, the Walnut Lane Bridge has a total length of 585 feet and a width of 60 feet. From the surface of the bridge 147 feet above the Wissahickon Creek, one has an incredible view of the valley beneath them. When the bridge is seen from below on Forbidden Drive, a person can take in the true grandeur of this man-made wonder. (Rose Company, c. 1908.)

WALNUT LANE BRIDGE. From this angle, the largest of the five great spans of concrete that support the bridge can truly be appreciated. This immense center arch spans 233 feet, allowing the bridge to stretch from one bank of the Wissahickon to the other. The two men standing at the base of the arch are dwarfed by the colossal size of the structure. (Post Card Distribution Company, c. 1910.)

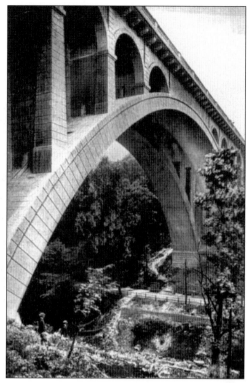

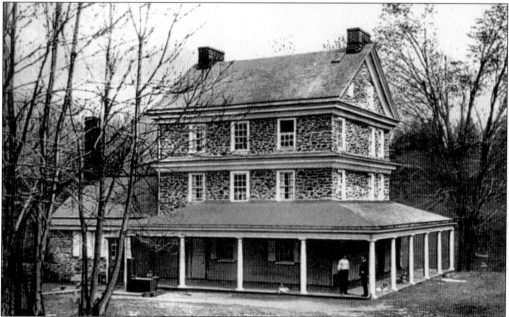

OLD MONASTERY. This lovely Colonial stone house at Kitchen Lane was built c. 1745 by George Gorgas. Because Gorgas, a member of the Society of Brethren (Dunkers), held religious services here, the home became known as the Monastery. A baptismal pool was located just a short distance away. The property was acquired by the Fairmount Park Commission in 1896. (Detroit Publishing Company, 1905.)

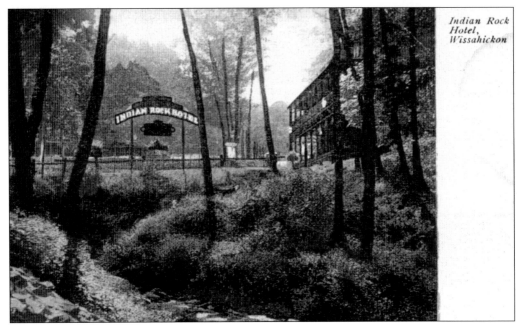

INDIAN ROCK HOTEL. A large wooden sign identifies the location of the Indian Rock Hotel. Not the first establishment in the area with this name, it was, however, to be the last. Suffering the fate of others of its kind, the hotel was demolished, leaving the Valley Green Inn to serve as the last of the Wissahickon Valley's roadhouses. (Douglass Post Card Company, c. 1905.)

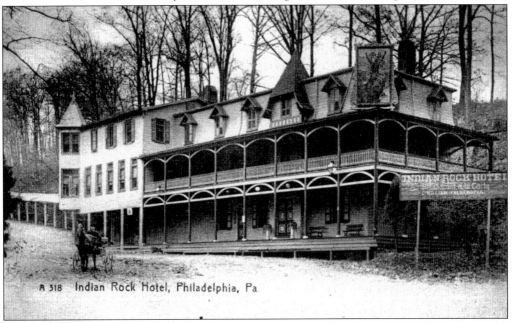

INDIAN ROCK HOTEL. The three-story, wooden Indian Rock Hotel was located at the foot of Monastery Avenue. While under the proprietorship of William Frankenberg, it served as a lodging place as well as a "restaurant a la carte." Note the horse-and-carriage shelters at the rear of the building. During the warmer months, guests could sit on the porches and enjoy the surrounding view. (Rotograph Company, c. 1905.)

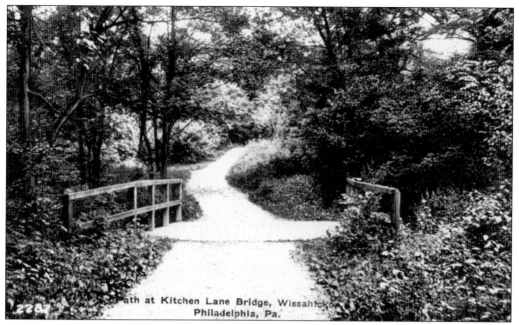

PATH AT KITCHEN LANE. Dense vegetation grows right up to the edge of this narrow dirt pathway. In the foreground, a small footbridge passes over a feeder stream heading for Wissahickon Creek. This section of the valley was noted not only for its rustic, scenic beauty, but also for its proximity to the Monastery. (Unknown, *c.* 1910.)

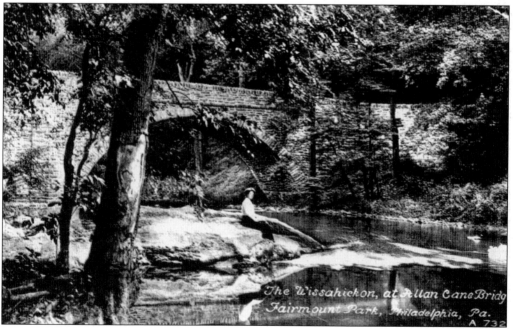

ALLAN LANE BRIDGE. A young lady sits at the edge of the creek in front of the stone-arched Allen Lane Bridge. This bridge connected Mount Airy and Roxborough by way of Gorgas Lane. Now more commonly known as the Mount Airy Avenue Bridge, the stone span seen here replaced a covered bridge that was destroyed by a flood in the late 1800s. (Unknown, *c.* 1910.)

SCENE ALONG WISSAHICKON DRIVE. This is a view along Forbidden Drive, also referred to as Upper Wissahickon Drive, as it appears above Allen Lane. Here, on the west bank of the Wissahickon Creek, the treelined gravel road leads northward toward the Livezey House and mill ruins. The house and ruins lie on the other side of the creek. (Post Card Distribution Company, c. 1910.)

AT GORGAS LANE. A group of bicyclists pauses to rest on a bench along Gorgas Lane. At the time, park rules required that bicycles have a bell capable of being heard at a distance of 30 yards, or the rider could be fined $5. Gorgas Lane runs from Ridge Avenue in an eastward direction until ending at Forbidden Drive. (World Post Card Company, c. 1905.)

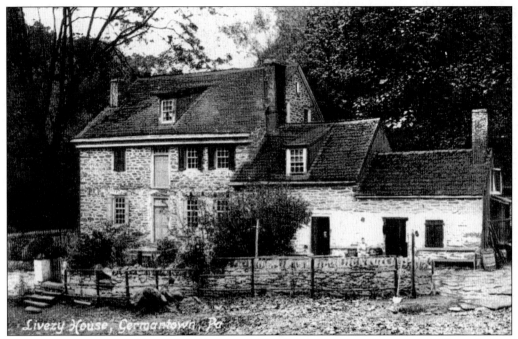

LIVEZY HOUSE. Originally named Glen Fern, this picturesque stone house was built on the east bank of the Wissahickon Creek, likely in the year 1725, by Thomas Shoemaker. Here, he also constructed a gristmill that was the largest in Colonial America. The property was then sold to Thomas Livezey on October 10, 1749, and remained in his family for 121 years. (Illustrated Post Card Company, *c.* 1908.)

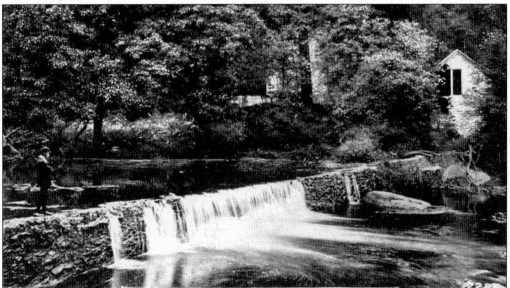

THE FALLS NEAR LIVEZEY MANSION. A boy stands on top of a milldam that extends across the width of the creek. This is one of the remains of the old mill that existed here near the Livezey House. Dams such as this were common along the Wissahickon in its industrial era. By the time this postcard image was taken, these were merely curiosities from days gone by. (Post Card Distribution Company, *c.* 1914.)

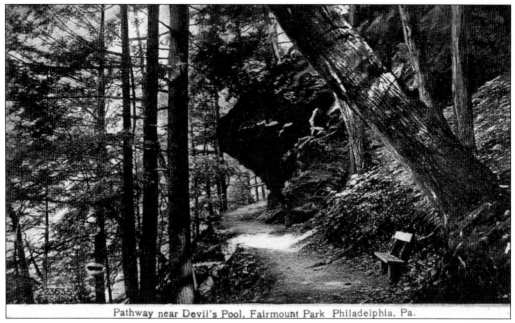

Pathway near Devil's Pool, Fairmount Park Philadelphia, Pa.

PATHWAY NEAR DEVIL'S POOL. A narrow dirt pathway leads to one of the natural wonders of the area: the Devil's Pool. Here, an overhanging rock juts out over the trail. The Wissahickon Valley contains many interesting geologic features and rock formations that can be investigated by curious hikers and ramblers. (Post Card Distribution Company, *c.* 1910.)

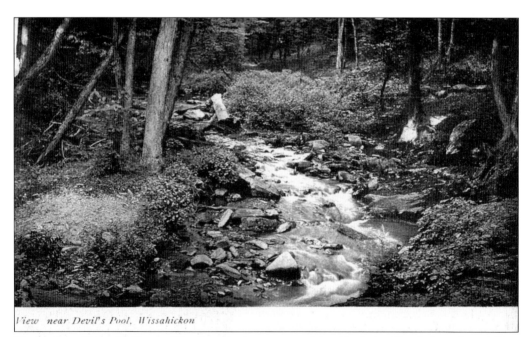

View near Devil's Pool, Wissahickon

VIEW NEAR DEVIL'S POOL. The fast-moving waters of the Cresheim Creek flow downhill to empty into the Devil's Pool. Eventually, this water will make its way to the Wissahickon Creek only a short distance away. The name Cresheim originated with the early German settlers, who named the valley area here after their home in Europe. (Douglass Post Card Company, *c.* 1904.)

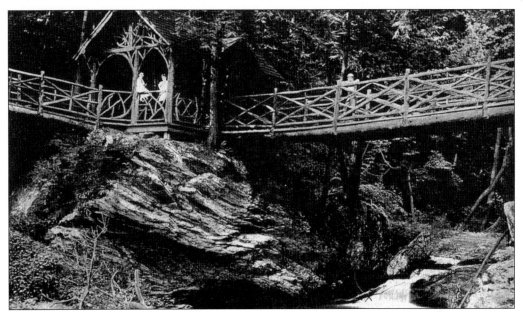

RUSTIC BRIDGE—DEVIL'S POOL. Set amongst giant rocks, near where the Cresheim Creek joins the Wissahickon, is a deep pool of water called the Devil's Pool. Legend states that the local Native Americans held spiritual gatherings here. Some people have even claimed that the pool is bottomless. One thing is for certain: the spot holds a unique fascination for those who view it. (Unknown, c. 1908.)

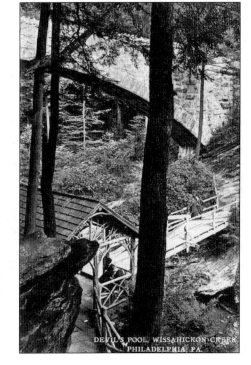

DEVIL'S POOL. During the early 1900s, a wooden bridge and open-air shelter awaited those who visited this scenic spot. The Devil's Pool was a popular attraction for those who ventured into this section of the Wissahickon Valley. The Livezey House is situated only a short walk away from the pool. (Unknown, c. 1910.)

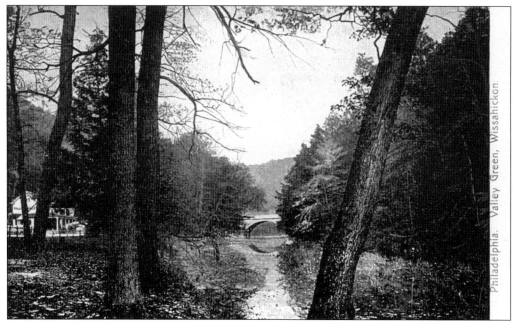

VALLEY GREEN. On the west side of the creek stands the Valley Green Inn, accessible by traveling along Forbidden Drive. In the distance, the Valley Green Bridge spans the waterway. At this location, canoes could be rented for a leisurely paddle up or down the stream. (World Post Card Company, c. 1905.)

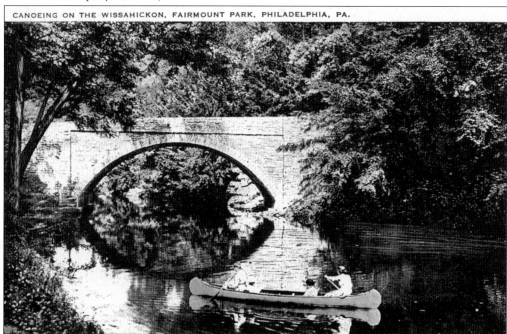

CANOEING ON THE WISSAHICKON. Built in 1832, this stone bridge's single, graceful arch forms a perfect oval. Its reflection in the quiet waters of the creek presents a wonderful visual effect for the canoe full of young ladies gliding toward shore. This area has long been admired for its beauty and serenity in any season. (Buffalo Post Card Company, c. 1917.)

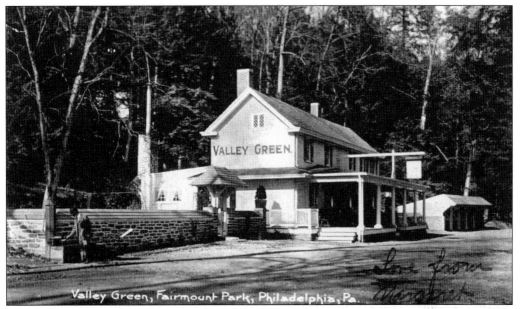

VALLEY GREEN. Standing on land once owned by the Livezey family, the Valley Green Inn is the only survivor of the Wissahickon resort era. Built in 1850, it replaced an earlier inn at this site. It and the surrounding 66 acres became part of Fairmount Park in 1872. After falling into disrepair, the inn was saved from demolition in 1899 by a group of local citizens who had it restored. (Rotograph Company, c. 1905.)

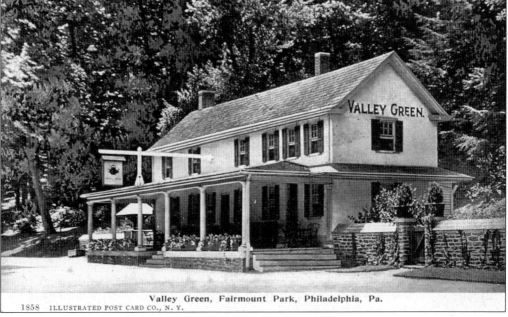

VALLEY GREEN. Located along Forbidden Drive, the Valley Green Inn is one of the best-known landmarks in the Wissahickon Valley. During the early 1900s, it was a favorite stopping place for sleighing parties in the winter and carriage riders in the summer. The establishment was most recently restored in 2002 and is once again open to the public for dining. (Illustrated Post Card Company, c. 1905.)

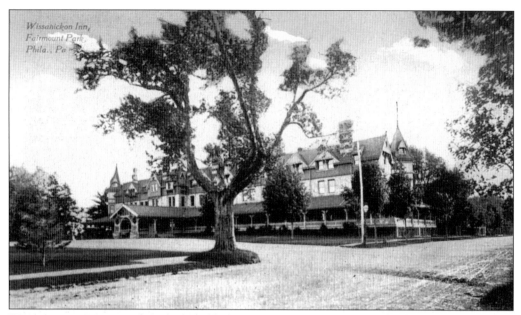

WISSAHICKON INN. Built and owned by Henry H. Houston, the Wissahickon Inn opened for business on May 30, 1884. Built in a U shape, it stood three stories and measured 236 feet by 227 feet by 227 feet. Its porch wrapped entirely around the structure, and a covered entranceway provided shelter for arriving carriages. Home to the Chestnut Hill Academy since 1901, the building has been placed on the National Register of Historic Places. (Unknown, c. 1908.)

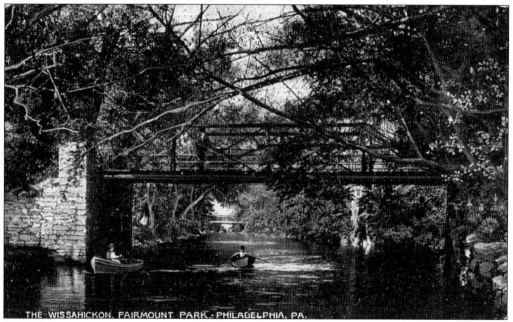

THE WISSAHICKON. Rowing along the Wissahickon under the shade of overhanging trees, two boats pass beneath the Hartwell Avenue Bridge. This narrow iron bridge, which no longer exists, was located just a short distance from Valley Green. On the other side of the bridge is Wise's Mill Road, which dates back to 1738. (Unknown, c. 1906.)

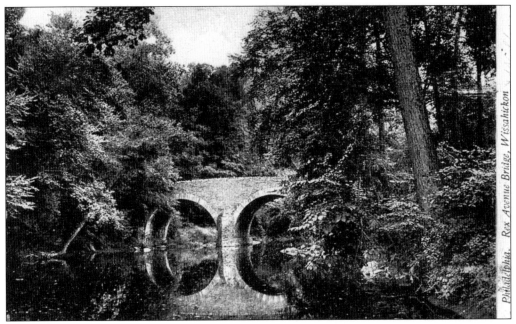

REX AVENUE BRIDGE. The double-arched, stone Rex Avenue Bridge stands dwarfed by the trees nearby. Sometimes referred to as the Indian Rock Bridge, it is located in a region especially known for towering hemlock trees and rugged terrain. Scenery such as this helped to attract people to the Wissahickon Valley. (World Post Card Company, c. 1907.)

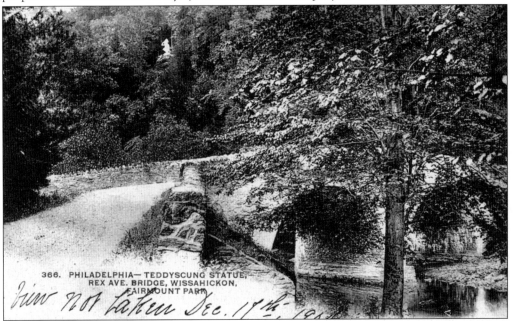

REX AVENUE BRIDGE. As parkgoers traveled down the road to the Rex Avenue Bridge, they entered one of the wildest portions of the Wissahickon Valley. From this vantage point at the approach to the bridge, the crouching figure of Tedyuscung is visible perched upon the distant Indian Rock. On the eastern end of the bridge, a path leads up to the statue. (World Post Card Company, c. 1904.)

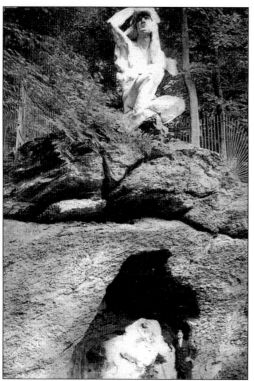

STATUE OF TEDYUSCUNG. On the east side of the Wissahickon Creek, about 100 yards north of Rex Avenue, is the outcropping known as Indian Rock or Council Rock. The Lenni Lenape Indians were thought to have held gatherings here. In 1902, a statue of Chief Tedyuscung was placed on its summit, replacing a crude wooden carving that had previously stood there. (Leighton & Valentine, *c.* 1911.)

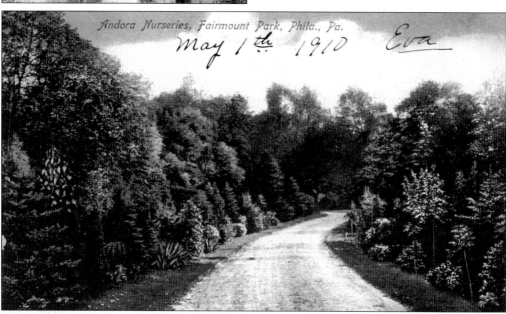

ANDORA NURSERIES. Once located at the northern end of Fairmount Park's Wissahickon Valley, the Andorra Nursery grew a wide variety of plant species. Tulip poplar, black cherry, and beech trees shared growing space with exotic plants from around the world. Today, the grounds of the former nursery make up part of the Wissahickon Environmental Center, which is dedicated to promoting "a better understanding of the natural world of the Wissahickon." (P. Sander, *c.* 1910.)

Six
STATUES, FOUNTAINS, AND MONUMENTS

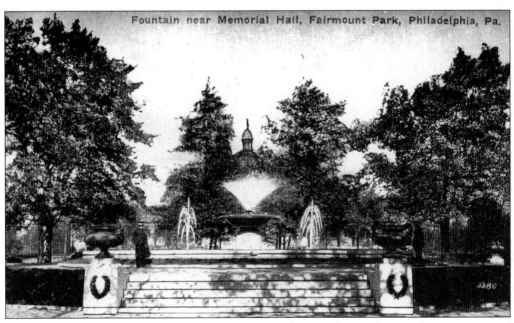

FOUNTAIN NEAR MEMORIAL HALL. On a terrace at the top of a set of steps, a large, ornamental fountain sprays water into the air. Such pieces of functional artwork, along with the many statues and monuments located throughout the park, help to create an aesthetic atmosphere. Many of these pieces were commissioned and purchased by the Fairmount Park Art Association, which was created in 1871. (Unknown, c. 1918.)

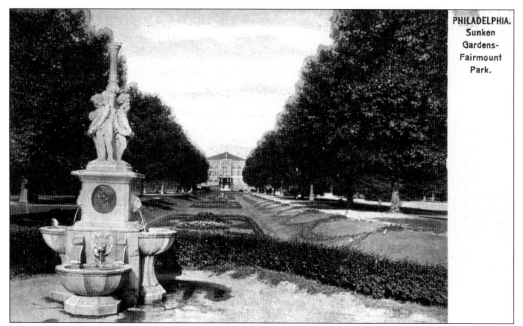

SUNKEN GARDENS. At the western end of the Sunken Gardens stands a marble fountain on top of which are the figures of several young children. From all four sides of the pedestal, water flows from the mouths of carved lions' heads and into basins. (Raphael Tuck & Sons, *c.* 1905.)

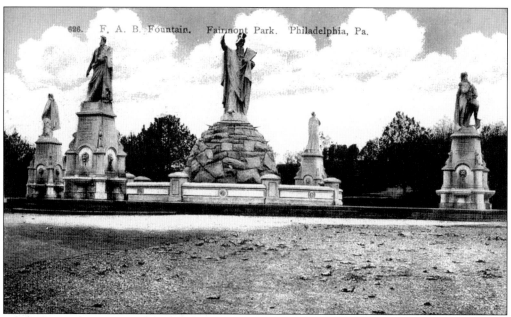

CATHOLIC ABSTINENCE FOUNTAIN. Sculpted by Herman Kirn for the 1876 Centennial Exposition, the Catholic Total Abstinence Fountain consists of five large statues. Honored are John Barry, Charles Carroll, Moses, Father Matthew, and Archbishop Carroll. The original cost of the marble artwork and fountain was $54,400 and was sponsored by the Catholic Total Abstinence Union of America. (Unknown, *c.* 1910.)

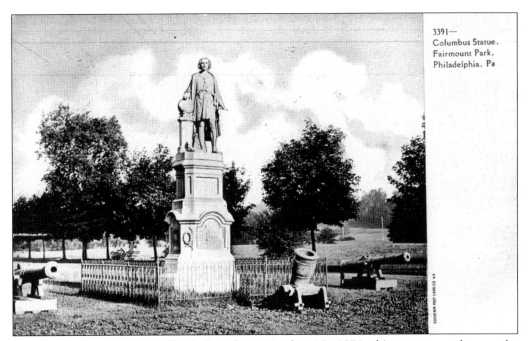

COLUMBUS STATUE. Formally dedicated on October 12, 1876, this monument honors the explorer Christopher Columbus. The statue was initially placed along Belmont Avenue near Memorial Hall. Purchased for $18,000 with money raised by the Columbus Monument Association, it was the country's first publicly funded monument to this man. (Souvenir Post Card Company, c. 1907.)

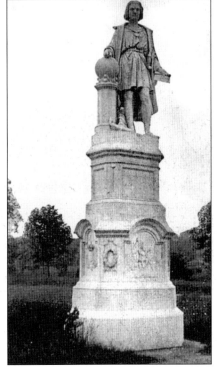

STATUE OF COLUMBUS. Thought to be the work of Emanuele Caroni, the likeness of Columbus stands upon a pedestal of Italian marble. He is depicted with his right hand resting on a globe, his left holding a scroll, and an anchor at his feet. In 1982, the statue was refurbished and relocated to Marconi Plaza in South Philadelphia. (Illustrated Post Card Company, c. 1899.)

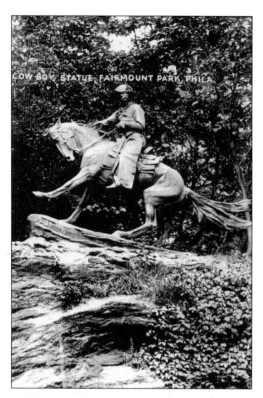

COWBOY STATUE. In 1908, the Fairmount Park Art Association commissioned this realistic depiction of an American cowboy. It is the only large-scale bronze sculpture created by famed western artist Frederick Remington (1861–1909). Placed on a rocky ledge facing west, it is located along East River (Kelly) Drive just north of the Girard Avenue Bridge, a selection made by the artist. (Grogan Photo, c. 1915.)

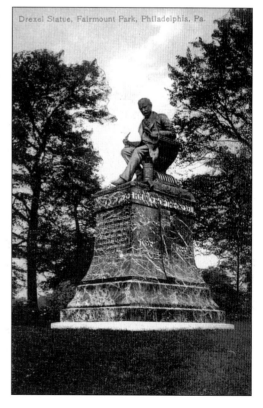

DREXEL STATUE. This bronze statue was sculpted by Moses Ezekiel to honor Anthony J. Drexel, Philadelphia financier and philanthropist. In 1891, Drexel established an institution that later became Drexel University. The statue, unveiled in June 1905, stood on the north side of Lansdowne Drive about 75 yards east of Belmont Avenue. It has since been removed and relocated to the Drexel University campus. (Unknown, c. 1910.)

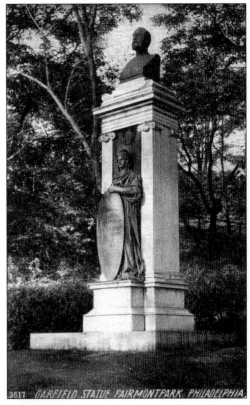

GARFIELD STATUE. Honoring the 20th president of the United States, James Garfield, this bronze bust was sculpted by Augustus Saint-Gaudens. The architect on the project was Stanford White. At the base of the pedestal stands the allegorical figure of the Republic. Funded by public donations, the bust was erected in 1896 on what is now Kelly Drive, just below the Girard Avenue Bridge. (Souvenir Post Card Company, c. 1909.)

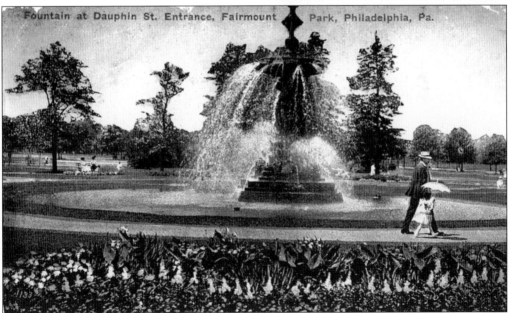

FOUNTAIN AT DAUPHIN STREET ENTRANCE. Streams of water pour from the Grand Fountain, which was placed near the Dauphin Street entrance to the East Park. The bronze-iron decorative fountain was erected in 1879. Nearby was the start of the park trolley line, from whence passengers were transported to locations throughout the park. (S. M. Company, c. 1915.)

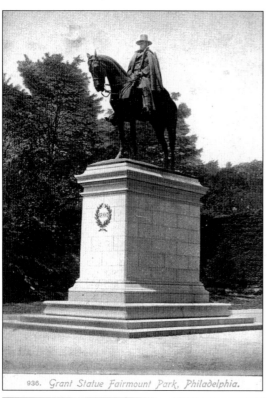

GRANT STATUE. This likeness of Ulysses S. Grant is the work of Daniel Chester French, the famous sculptor of the Lincoln Memorial, while the horse was created by Edward C. Potter. The magnificent statue was dedicated on April 27, 1899, on the 75th anniversary of Grant's birthday. In attendance at the unveiling were Pres. William McKinley, Mrs. Grant, and numerous other dignitaries. (Philadelphia Post Card Company, c. 1906.)

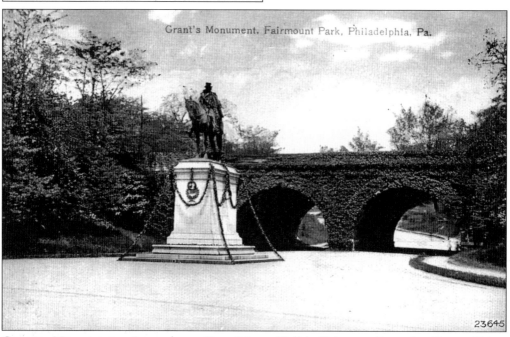

GRANT MONUMENT. Located on East River (Kelly) Drive at Fountain Green Drive, Gen. Ulysses S. Grant's equestrian statue was cast in bronze in Philadelphia. It was then placed upon a granite pedestal designed by Frank Miles Day. The cost of this five-ton statue, along with its 16-foot-high pedestal, was $32,675.35. (Unknown, c. 1909.)

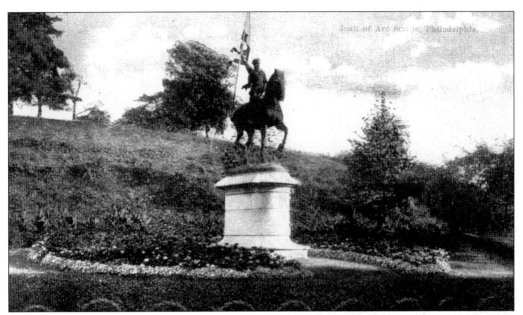

JOAN OF ARC. This equestrian monument to the French heroine Joan of Arc is the work of Emmanuel Fremiet. The statue was originally placed at the east end of the Girard Avenue Bridge. Its official unveiling ceremony was held on November 15, 1890. However, in 1948, it was removed and placed at its present location on East River (Kelly) Drive near the art museum. (Rosin & Company, c. 1910.)

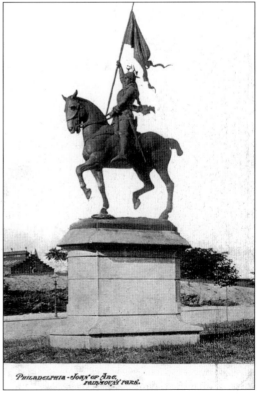

JOAN OF ARC. Standing 15 feet tall on a pedestal just over 8 feet high, the bronze likeness of Joan of Arc strikes a majestic pose. Joan of Arc is depicted sitting gallantly upon her horse with banner held high in triumph. To some, this is considered a true masterpiece of sculpture. There are four other castings of this statue—three in France and one in Australia. (World Post Card Company, c. 1904.)

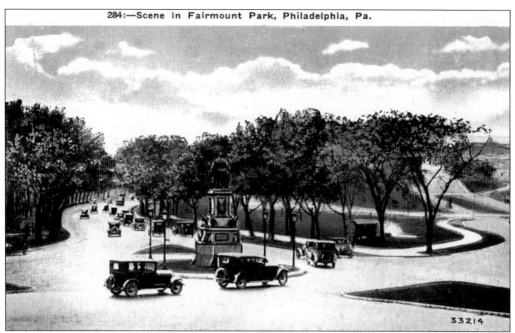

SCENE IN FAIRMOUNT PARK. Automobile traffic passes the monument to Abraham Lincoln that stands on an island at the junction of East River (Kelly) Drive and Lemon Hill Drive. The statue and its pedestal were erected at a cost of $33,000. This tribute to our 16th president was paid for with funds raised by the Lincoln Monument Association. (P. Sander, *c.* 1923.)

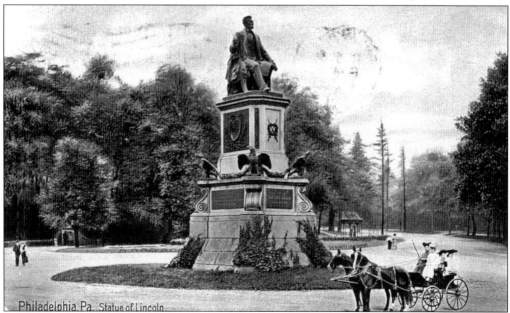

STATUE OF LINCOLN. A horse-drawn carriage carrying park visitors stops to appreciate this monument to our martyred president. The bronze likeness of Lincoln, cast in Germany, is the work of sculptor Randolph Rogers. This highly detailed statue depicts a seated Lincoln holding a copy of the Emancipation Proclamation. Symbolically, he was positioned so that he was facing southward. (H. C. Leighton Company, *c.* 1908.)

LINCOLN'S STATUE. Dedication ceremonies for the monument occurred in 1871 and drew an estimated 50,000 people. The 9.5-foot sculpture of Abraham Lincoln sits atop a pedestal that in itself is more than 22 feet tall. The pedestal is decorated with four eagles, as well as the coat of arms of the city of Philadelphia. A plaque on the side of the monument is inscribed, "To Abraham Lincoln from a grateful people." (American Historical Art Company, c. 1904.)

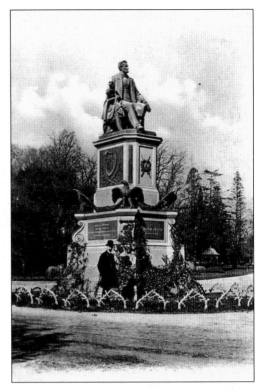

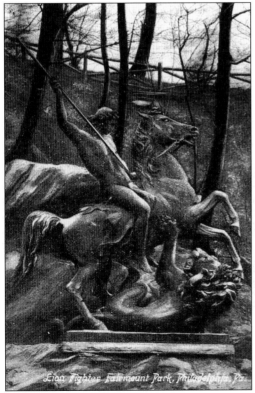

LION FIGHTER. On East River (Kelly) Drive below the Girard Avenue Bridge, this bronze statue stands on a natural outcropping of rock. Depicted is a heroic battle between a man on horseback and a lion. This work of prominent German artist Albert Wolff was unveiled in the park in June 1897. (Illustrated Post Card Company, c. 1910.)

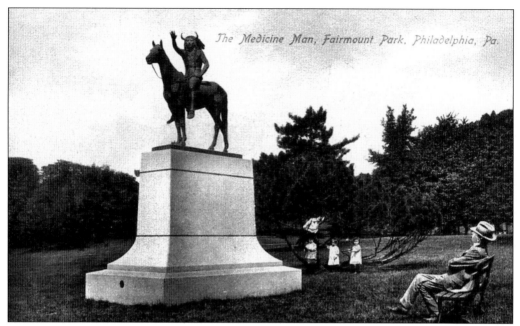

THE MEDICINE MAN. A man sits on a park bench, admiring the magnificent bronze equestrian statue of a Native American medicine man. The artwork is located near the Dauphin Street entrance to East Park. The sculpture was placed in the park in 1903. The site was selected by the artist, Cyrus E. Dallin. (H. C. Leighton Company, c. 1910.)

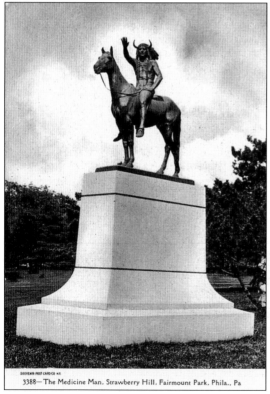

THE MEDICINE MAN. This acclaimed sculpture stands seven and a half feet tall upon a granite pedestal. When the statue was erected, a sealed metal box containing coins, newspapers, and printed materials dealing with local history was placed in its foundation. (Souvenir Post Card Company, c. 1906.)

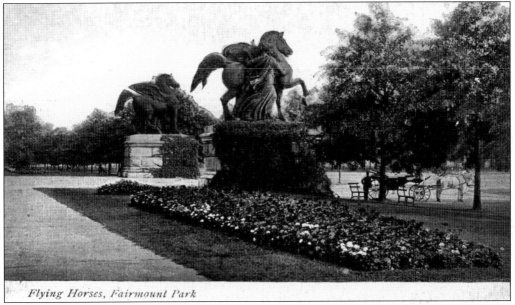

Flying Horses, Fairmount Park

FLYING HORSES. These two splendid winged horses known as the Pegasus Group are the work of Vincent Pilz of Vienna. The bronze horses stand atop pedestals located at the entrance to Memorial Hall. Originally commissioned for the Vienna Opera House, they were scheduled to be melted down, until purchased with funds raised by Robert H. Gretz and 22 other Philadelphians. (Douglass Post Card Company, *c.* 1908.)

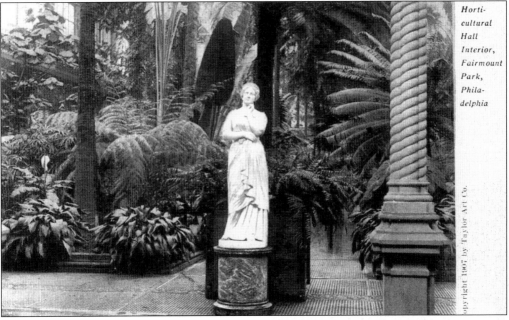

Horticultural Hall Interior, Fairmount Park, Philadelphia

HORTICULTURAL HALL INTERIOR. The displays of flora in Horticultural Hall were enhanced by the placement of a number of statues amongst the exhibits. Most of these were of classical subjects. This marble statue is titled *Penseroso* and is the work of sculptor Joseph Mozier. Purchased by the Fairmount Park Art Association, it was first displayed in 1874. (Taylor Art Company, *c.* 1907.)

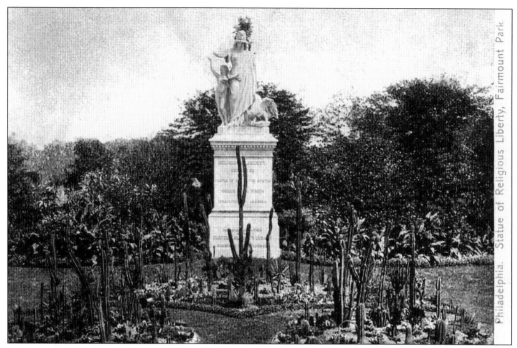

STATUE OF RELIGIOUS LIBERTY. Dedicated to the freedom of religion in the United States, this statue was placed near the entrance to Horticultural Hall. During the early 1900s, the sculpture was surrounded by a series of cactus gardens. Erected in 1876 by the Independent Order of B'nai B'rith and Israelites of America, it was the work of sculptor Moses Ezekiel. In 1985, the artwork was relocated to 55 North Fifth Street. (World Post Card Company, *c.* 1906.)

A SEAWEED FOUNTAIN. Winner of the Widener Gold Medal in 1922, *A Seaweed Fountain* was created by Beatrice Fenton. Fenton (1887–1983), a native Philadelphian, is best known for her sculptures dealing with water. She was a member of the Philadelphia Ten, a noted women's art group that helped promote the work of female artists. (Unknown, *c.* 1924.)

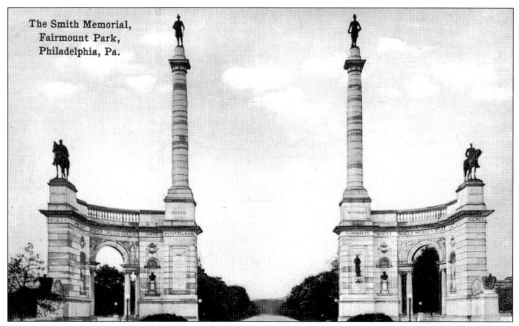

THE SMITH MEMORIAL. This impressive monument on Lansdowne Drive near Memorial Hall forms a gateway into West Park. Built to commemorate Pennsylvania's Civil War military and naval heroes, it took more than 15 years to complete (1897–1912). Fifteen individual sculptures by various artisans portray such famous men as Generals Hancock, Meade, McClellan, and Reynolds and Admirals Porter and Dahlgren. (Sabold-Herb Company, *c.* 1914.)

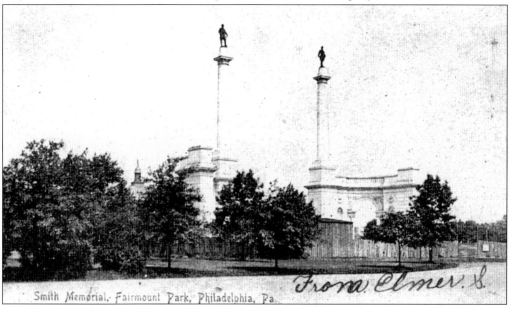

SMITH MEMORIAL. This very early postcard view shows what appears to be a wooden fence surrounding the memorial. This most likely kept people away while work was being completed. Noticeably missing from the top of the monument's walls are the large equestrian statues of Gen. George B. McClellan and Gen. Winfield Scott Hancock. (Independent Photo-Card Company, *c.* 1904.)

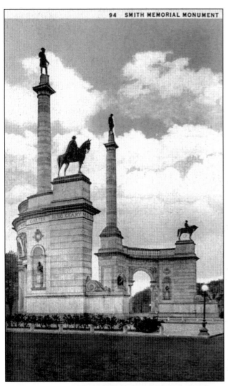

SMITH MEMORIAL. Constructed with funds donated by Richard Smith, the memorial was designed by architect James Windrim in the Italian Renaissance style. At the rear of the structure, a most unusual feature is found: the "whispering benches." Sit at one end with your head close to the wall, and your whisper can clearly be heard by a friend on the other side. (Lynn Boyer, c. 1925.)

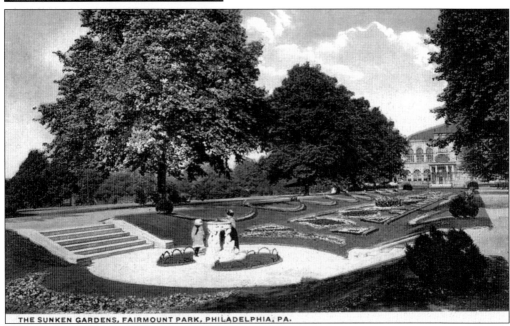

SUNKEN GARDENS. At the Sunken Gardens, with Horticultural Hall in the distance, two people take interest in the sculpture known as *The Sundial*. A traditional sundial sits upon a circular table supported by the marble figures of four young women, each of which represents a different season of the year. This piece of artwork, installed in May 1905, was created by Alexander S. Calder. (Post Card Distribution Company, c. 1918.)

INDIAN ROCK. Since 1902, this marble statue has stood on Indian Rock near Rex Avenue in the Wissahickon. The work of J. Massey Rhind, it is called *Statue of Tedyuscung*. Tedyuscung was a "spokesman and leader" of his tribe, the Lenni Lenapi Indians. The crouching warrior, holding a tomahawk, was mistakenly given the headdress of a Western Plains Indian. The statue was positioned facing westward, always looking off toward the setting sun. (Illustrated Post Card Company, c. 1907.)

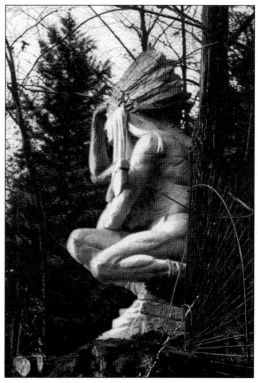

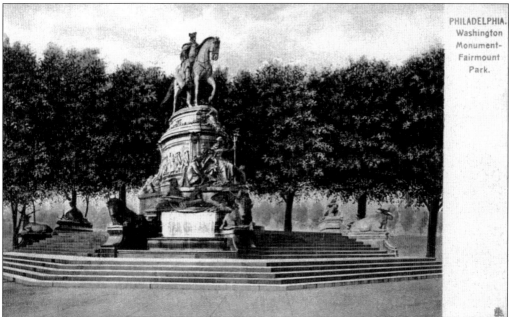

WASHINGTON MONUMENT. Standing 44 feet tall, this bronze and granite monument dedicated to George Washington is considered to be among the finest equestrian statues in the world. This colossal work of art was commissioned by the Society of the Cincinnati of Pennsylvania. After 80 years of planning, the monument was finally completed and dedicated in May 1897 by Pres. William McKinley. (Raphael Tuck, c. 1905.)

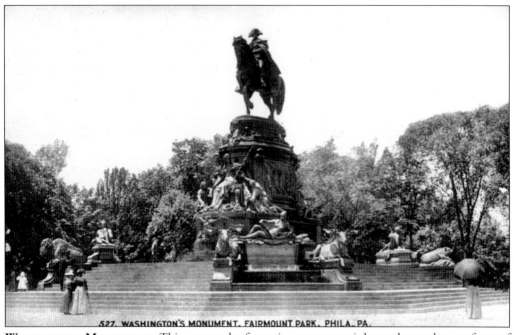

WASHINGTON MONUMENT. This spectacular fountain monument is located near the east front of the Philadelphia Museum of Art and is the work of German sculptor Rudolf Siemering. Multiple detailed representations of animals and people encircle the decorated pedestal, upon which stands the mounted likeness of George Washington. (Douglass Post Card Company, *c.* 1904.)

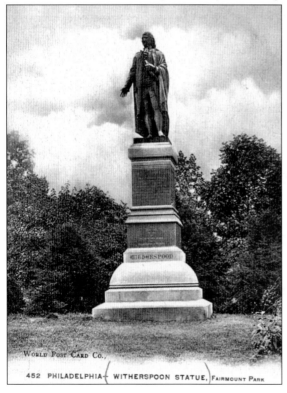

WITHERSPOON STATUE. John Witherspoon is honored with this statue, placed in West Park just northeast of Horticultural Hall. A Revolutionary War patriot, Presbyterian clergyman, and signer of the Declaration of Independence, Witherspoon also served as president of Princeton University. The statue, commissioned by the Presbyterian Church General Assembly, dates from 1875 and cost $25,000. (World Post Card Company, *c.* 1906.)

Seven
Park Miscellany

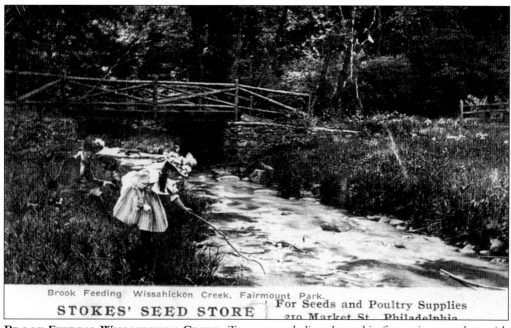

Brook Feeding Wissahickon Creek. Two young ladies, dressed in fine attire complete with fancy hats, enjoy an afternoon alongside a fast-moving stream. Experiencing such a country-like setting, away from normal city life, was a lure that many could not resist. This has always been one of the park's major enticements. (Goggins, *c.* 1905.)

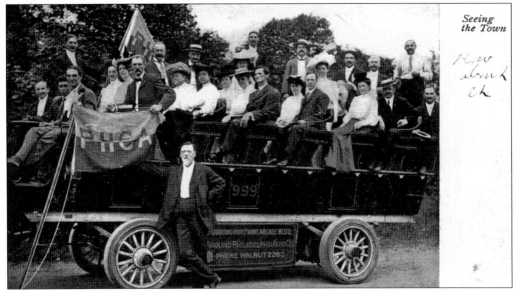

SEEING THE TOWN. Open-air buses transported patrons on tours of Philadelphia and beautiful Fairmount Park. Round-trip sightseeing tours left from Center City and cost $1. Here, a large group, apparently part of an organization identified as the PHCA, poses for the camera. (Douglass Post Card Company, c. 1906.)

SEEING PHILADELPHIA. This company's tour buses departed from Keith's Theatre on Chestnut Street to make the rounds of all the major attractions. Fairmount Park was, of course, a popular destination. This open-air "automobile" has stopped to allow passengers to admire the grand monument to George Washington. (Unknown, c. 1920.)

PARK TROLLEY. Before the automobile became the standard means of transport, open-air trolleys such as this ran trips "skirting and through the heart of the park." During the fall and winter months, "comfortably heated" enclosed cars were used. With almost nine miles of track and numerous stations, passengers could reach all of the major destinations within the park's boundaries. (World Post Card Company, c. 1905.)

PARK TROLLEY. Traveling through scenic areas helped make the open-air trolleys a memorable part of a day's outing in the park. The trolley tracks were originally laid in 1896–1897. The Fairmount Park Transportation Company operated the system until the final official run on September 9, 1946. (O. S. Bunnell, c. 1910.)

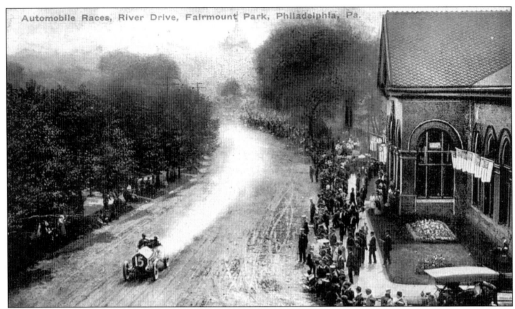

AUTOMOBILE RACES. Between the years 1908 and 1911, some of the leading racecar drivers of the day participated in contests of speed in Fairmount Park. These events were very popular with race fans and attracted many spectators. However, they were discontinued when several of the city's more influential citizens expressed their feelings about them being an "unsuitable" form of entertainment. (Souvenir Post Card Company, c. 1910.)

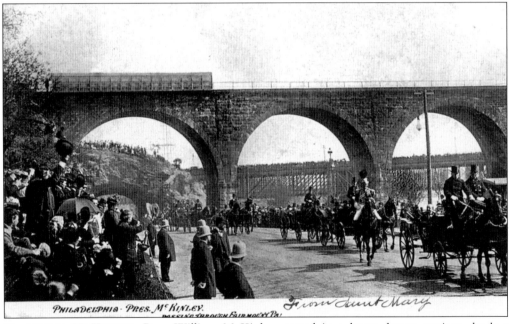

PRESIDENT MCKINLEY. Pres. William McKinley, seated in a horse-drawn carriage, leads a procession north along East River (Kelly) Drive. It is possible that this parade was part of the dedication ceremonies for the Ulysses S. Grant statue in 1899. McKinley was assassinated in 1901 while attending the Pan-American Exposition in Buffalo, New York. (World Post Card Company, c. 1905.)

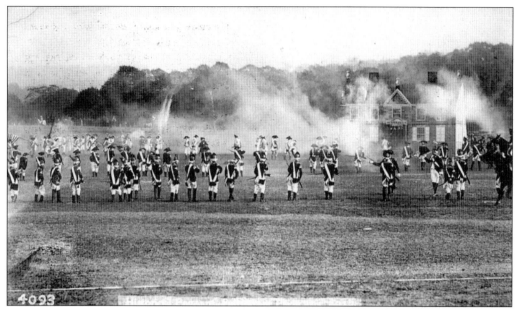

HISTORICAL PAGEANT. A Revolutionary War exhibition, involving men dressed in authentic military costume, was part of a historical pageant held in Fairmount Park in October 1912. This was possibly a re-enactment of the Battle of Germantown, which took place not far from here on October 4, 1777. Although that battle was considered an American defeat, it did much to build self-confidence in the Colonial troops. (William H. Rau, 1912.)

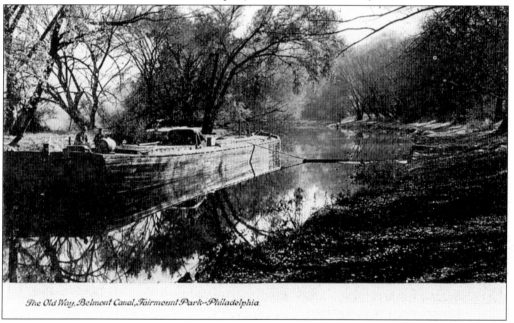

THE OLD WAY, BELMONT CANAL. During the 1800s, an extensive system of canals was constructed along the Schuylkill River. Here, on the west side of the river at the Belmont Canal, sits a flat-bottomed canal boat. This type of craft was once commonly used for hauling coal from upstate Pennsylvania down to Philadelphia. These boats once docked near Montgomery Drive and Black Road. (Unknown, *c.* 1904.)

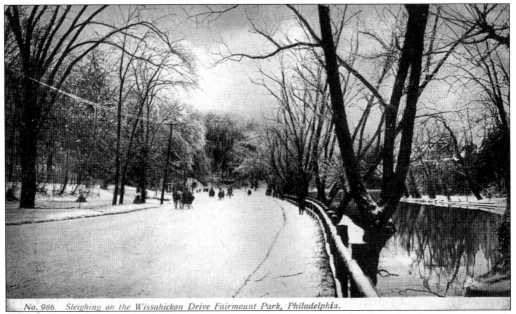

No. 986. Sleighing on the Wissahickon Drive Fairmount Park, Philadelphia.

SLEIGHING ON THE WISSAHICKON. Winter snows did not stop people from enjoying the pleasures of the park. Riding along in a horse-drawn sleigh on any of the many roads and paths was a fashionable custom, particularly in the Wissahickon area. Sleighing parties would often end up at the Valley Green Inn for refreshments and a chance to get warm. (Philadelphia Post Card Company, c. 1908.)

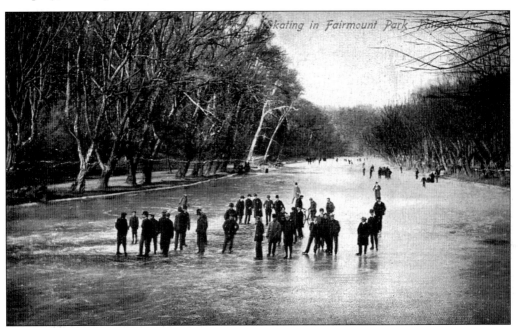

SKATING IN FAIRMOUNT PARK. Another favorite winter pastime in the park is ice-skating. Here, men enjoy a day on the ice. Two popular locations for this activity were the frozen waters of the lower Wissahickon Creek and the ice field at Valley Green. The surfaces of the various lakes were also used for this recreation. (Metropolitan News Company, c. 1908.)

THE PUMP. Three men stand at a sheltered water pump at an unidentified location. Water pumps such as this, along with the many natural springs, provided fresh water for picnickers and others enjoying the park. A 1916 guidebook listed 13 different pumps located within East and West Parks. (Unknown, *c.* 1910.)

NATURAL SPRING. Approximately 160 natural springs were situated throughout Fairmount Park. Many, like this one, were improved by adding stone façades and outlet pipes for better enjoyment and easier access to drinking water. In the 1960s, over concerns about water quality and public safety, they were all sealed to prevent usage. (Unknown, *c.* 1910.)

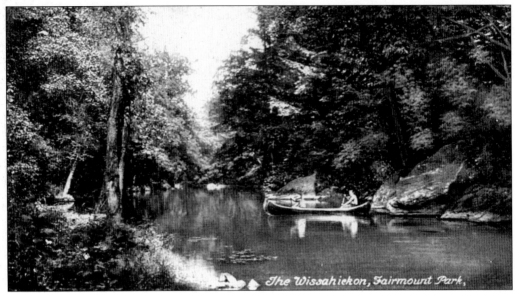

THE WISSAHICKON. The rugged geography, primeval forests, and natural beauty of the Wissahickon Valley have enchanted visitors for generations. In 1844, Edgar Allan Poe, in "Morning on the Wissahiccon," penned one of the greatest compliments to the region. He wrote of the Wissahickon Creek: "[It] is of so remarkable a loveliness that were it flowing in England, it would be the theme of every bard, and the common topic of every tongue." (Unknown, c. 1910.)

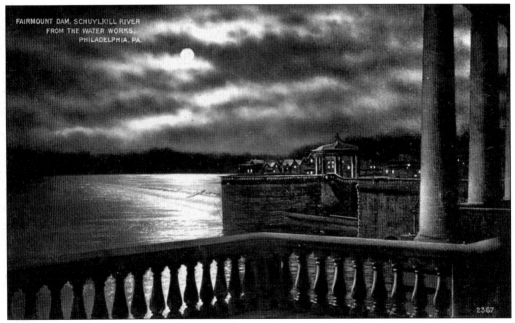

FAIRMOUNT DAM FROM THE WATER WORKS. The moon and the lights from Boat House Row reflecting off the surface of the Schuylkill create an almost dreamlike image. Tomorrow, a new day will provide the citizens of Philadelphia the chance to once again experience the countless treasures of Fairmount Park. (Unknown, c. 1909.)